# DORSET PUBS
## THROUGH TIME
Tim Edgell
& Hugh Elmes

AMBERLEY PUBLISHING

# Contents

For every book sold, a donation will be made to cancer charities.

First published 2013

Amberley Publishing
The Hill, Stroud
Gloucestershire, GL5 4EP

www.amberley-books.com

Copyright © Tim Edgell and Hugh Elmes, 2013

The right of Tim Edgell and Hugh Elmes to be
identified as the Author of this work has been
asserted in accordance with the Copyrights, Designs
and Patents Act 1988.

ISBN 978 1 4456 0814 3

British Library Cataloguing in Publication Data.

A catalogue record for this book is available from
the British Library.

Typeset in 9.5pt on 12pt Celeste.
Typesetting by Amberley Publishing.
Printed in the UK.

# Introduction

**Hugh's View**

I was born and bred in Dorset, and my interest in public houses first arose in the early 1960s, when I played in skiffle and folk groups. I met Tim in 2008, when he was writing his book *Dorset Pubs & Breweries,* and he asked whether I would collaborate with this edition looking at pubs past and present. Being a folk musician, I straight away thought of Bob Dylan and his 1962 song 'The Times They Are a-Changin' and felt I would like to write about the pubs as they were around that time.

Travelling around Dorset, it has been interesting to see the changes that have taken place in pubs. In the 1960s, landlords did not move on as they do today. They attracted their customers with their personalities and seemed to make a good living without serving hot food. Friday night was darts night, and they laid on only snacks of bread & cheese and pickled onions, which were always appreciated.

The annual pub coach outing was when young and old mixed for a trip to the seaside. When returning to the pub in the evening, the coach used to stop for comfort breaks. The ladies went on one side of the hedge and the men on the other. Sometimes you could hear the ladies scream as they encountered stinging nettles!

In those days most pubs consisted of a public bar, a lounge bar and a Bottle & Jug. Today they have one big bar. This has changed the acoustics and spoilt the atmosphere of the good old-fashioned pub. Saturday night was entertainment night, usually with a piano and a good singalong in the public bar. Today you have to listen to a Mrs Mills record to get the same atmosphere. There was always a haze of smoke and yellow nicotine stains on the ceilings. There was also the smell of ale and the good old pickled onion! Today you can purchase paint to achieve the effect of nicotine. I guess that's progress!

In the past, all pub lavatories were outside. It is only since pubs started serving food and government regulations came in that toilets have moved inside the premises.

I was rather worried when I was asked to join Tim on his quest. He asked me questions about what I thought of pubs today. I must admit the pubs have changed so much, but I still enjoy the public bar area where you can have a pint and enjoy a conversation. I must also say that if it was not for my wife Sue, who encouraged me to share my views on the past, I would not have helped with the book. I guess I am very lucky to have a wife who drives me to drink, helping me with the research!

**Tim's Round**

Yer, the pubs they have a-changed. Is that the end of the story? No; nothing stays the same and pubs will carry on changing. Pubs provide a window on society, so as society changes, so do most pubs.

The good old British pub is a unique institution and is in the top three 'must visit' list for tourists. Most pubs are under pressure as never before, but some have upped their game. Dorset pubs in general have responded well and have diversified in some cases. The Three Elms Inn at North Wootton and the White Horse at Stourpaine both contain a post office and store. As a result, pub closures in Dorset have been kept to a minimum compared to national figures of twelve pubs closing per week.

The main change at the inn is the loss of the camaraderie fostered by the character landlord and landlady. This change is inevitable. More pubs are managed these days, the population is more mobile and more socialising is done online. Social demographics have changed; for example the rural workforce has declined and the number of second home owners has risen. You want to visit your countryside local, but without it changing course to a country dining pub (remarketed gastropub) it probably will not be there.

Now I'm more partial to Motorhead and prefer Jon 'gone space truckin'' Lord at the keyboards, but there is no doubting that a great pub atmosphere is created when people of all drinking ages get together and enjoy live acoustic music.

Please read this book in conjunction with *Dorset Pubs & Breweries* by Tim Edgell (Amberley Publishing) and *Ye Olde Wareham Pub Crawl* by Hugh Elmes (self-published). The chapters of *Dorset Pubs Through Time* take an area of the county and follow a zigzag path northwards, like an old typewriter in reverse. Cheers and happy reading.

# Acknowledgements

Extra-special thanks to Sue Elmes for her hospitality during Tim's visits, her encouragement and help with the book.

Special thanks to Annie Blick for once again restoring so many images.

Many thanks to Phil Anderson, Rachael Aplin, Julia Ballard, Dave & Jackie Baugh and family, Richard Bell, Alan Brown, Anna Corbett, Emma & Russ Craven, Terence Davis, Mike Edgell, Andrew & Ann Evans, Jan Franklin, Sophie Green, Jolene Hamilton, Rob Hamon, Aaron Hardy, Eileen Hardy, Charlie Hathaway, Andrew Hawkes, Martin & Karen Helyar, Wendy & Peter Horne, Michaela Horsfield, Mark Jenkin, Andy Kiff, Andy Lane, Graham Legg, John Lemon, Pippa Lightbown, Mathew Locker, Rob Martin, Gladys Matthews, John & Linda McClements, Steve Millar, Russell Murfitt, the Naylor family, Cleeves Palmer, Sue Parran, Sharon & Don Pearce, Mike Peterson, Giles Smeath, Paul Smith, Rosie & Brent Smith, Megan Speer, Zena & Kevin Staunton, Richard Surtees, Andrew Swift, Clive Taylor, Dave & Wennona Taylor, David Tuffin, Steve & Martin Walsh, Scott Wayland, Kelvin Webb, John & Becky Whinnerah, Kevan Witt, and to everyone else who has given us help and refreshment along the way.

Barrie Pictures offer an excellent selection of old Dorset photographs on its website www.barriepictures.co.uk

Andy Lane actively collects Dorset brewery and pub memorabilia. He can be contacted on 07789 275242 or 01308 482132.

# East Dorset

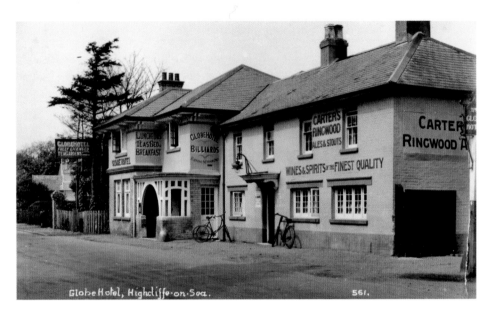

Globe Hotel, Highcliffe-on-Sea.                     561.

### Globe Hotel

The times they are a-changin'. Over the past century the Globe Hotel at Highcliffe-on-Sea has been owned by Carters Brewery, Strongs, and is now a Premier Inn owned by Whitbread. The original solid frontage remains but behind it is all change. Following the proven Premier Inn formula the decor is new wood, cream and claret with a large restaurant extension. The atmosphere is family-friendly rather than family-run. This formula is successful and in truth may have given the Globe a new lease of life.

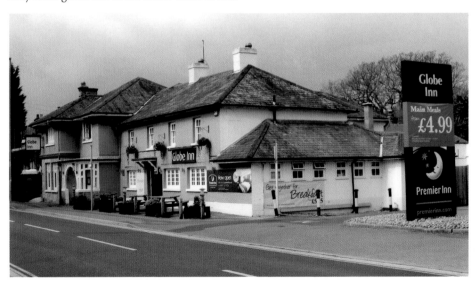

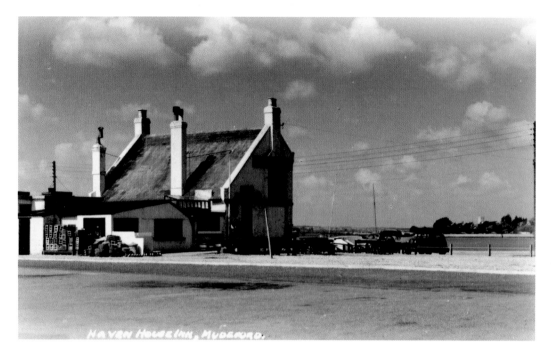

## Haven House

As Mudeford Quay has been developed the Haven House Inn can hardly be seen by approaching sailors. The pub is hemmed in by the Highcliffe Sailing Club and RNLI Lifeboat Station to the front and an enlarged café to the rear. One very pleasing aspect that remains is the Sundowners Terrace where, with a pint of Ringwood ale, glorious sunsets can be viewed. Once a smugglers' inn, the Haven House is now more civilised, but don't try to enter with children or wetsuits.

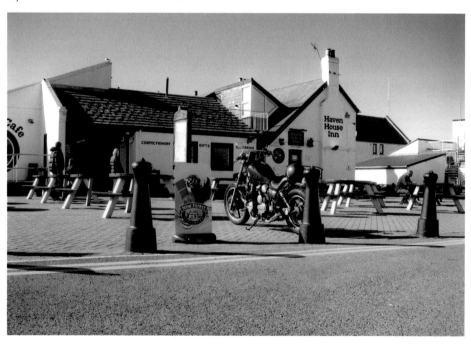

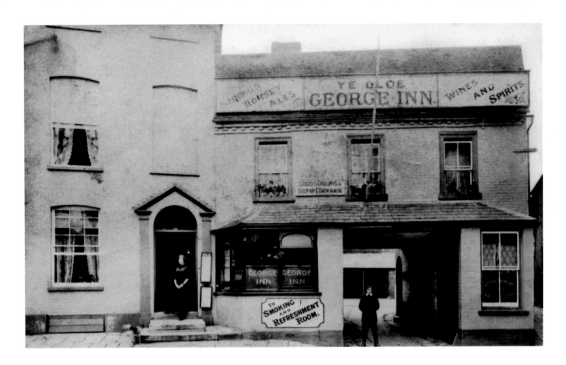

## Ye Olde George Inn

Ye Olde George Inn (affectionately known as YOGI) at Christchurch was previously the George Inn and in the seventeenth century the George & Dragon. Now it is the flagship pub for the cheekily named Dorset Piddle Brewery, which is based in Piddlehinton. In such an old building there are always ghostly tales. Here two grey ladies scratch and cry on quiet nights. Not that there are many quiet nights at the YOGI, as it continues to be an extremely popular pub.

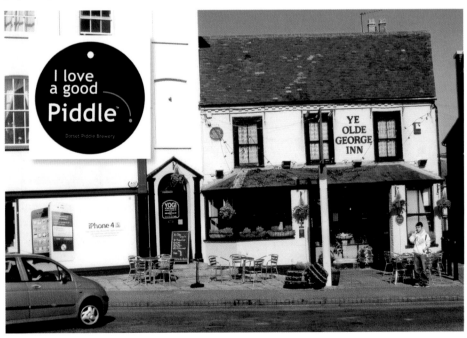

**Goat & Tricycle**

Previously, the multi-award-winning Goat & Tricycle in West Hill, Bournemouth, was two separate pubs. The Pembroke Arms was to the left – its superb old Marston's Dolphin Brewery tiled frontage remains. The Pembroke Shades, where the bar is now, was on the right. The Shades had a boxing club and it is claimed that Freddie Mills, who went to school opposite, trained here in his early years. He became World Light Heavyweight Champion in the late 1940s. (Top photograph courtesy of the *Bournemouth Echo*)

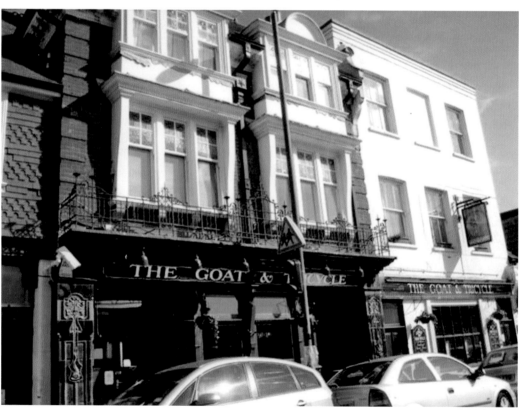

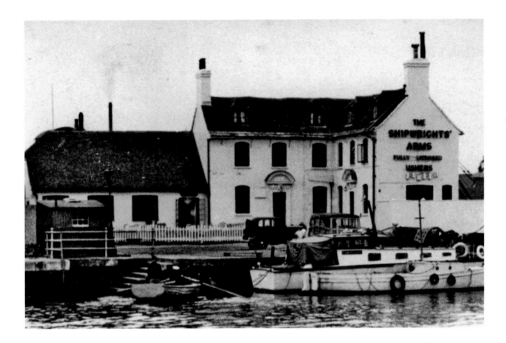

## Shipwrights' Arms

At the end of Ferry Road, Poole, the foundations of the Shipwrights' Arms collapsed and the popular inn was demolished in 1978. In the 1960s the Shipwrights' was known for its live entertainment. Until then pub music was provided mainly by a piano. Then a man named Peter Franklin started entertaining there, accompanying himself on a guitar. He had a repertoire of songs that got his audience singing. The more they sang, the more refreshment was required, so he was an immediate hit with the audience and landlord.

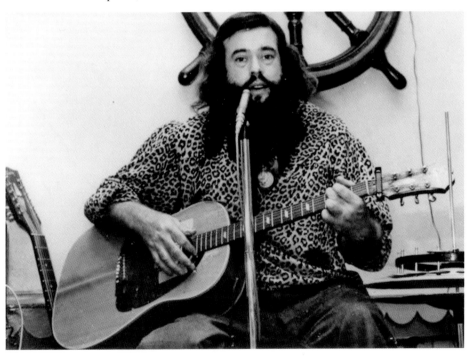

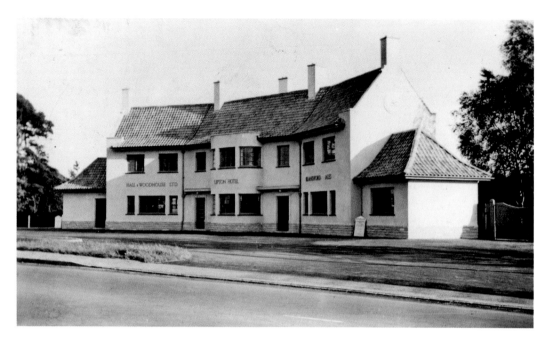

## Upton Hotel

The sad demise of the Upton Hotel is a graphic illustration of what is happening to many pubs across the land. Had property values not fallen, this sight would have been more common too. The hotel was once the hub of the community for the residents of Upton but as Bob Dylan observed, times have changed. Pubs are closing because of rising costs, competition from supermarkets and the recession forcing people to drink at home. The message about pubs is 'use it or lose it'.

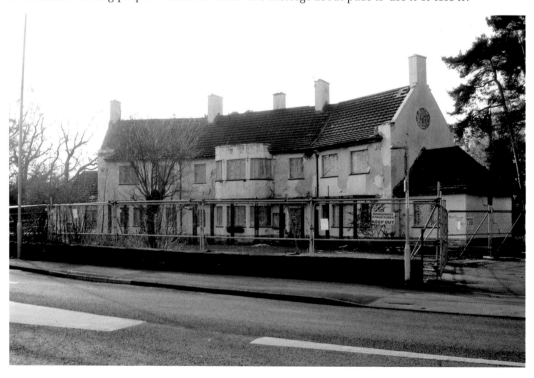

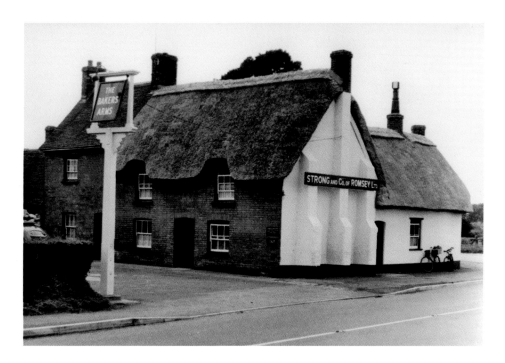

### Bakers Arms

Once by a rural T-junction, the Bakers Arms at Lytchett Minster is now just off the A35 bypass completed in 1980. Today it is more of an extended pub restaurant. Back in the 1960s beer was still served from a store at the back of the bar. The landlord, Hugh, had a wooden leg which made him unsteady on his feet. By the time he got back to the counter, quite a bit of your pint was on the floor. It just shows there were hops in it!

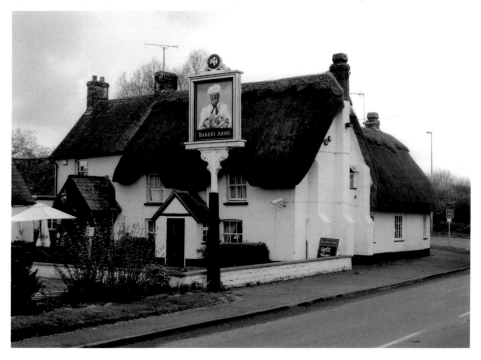

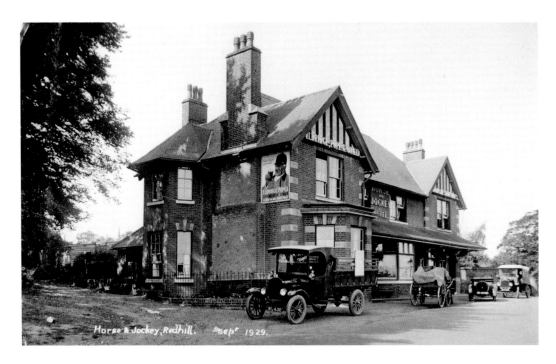

### Horse & Jockey

Nowadays it seems odd to find a pub called the Horse & Jockey at Red Hill, Bournemouth. Back in the 1920s a racecourse was established in nearby Ensbury Park, where the Leybourne Estate is now. Lester Piggott's father Keith rode at the last meeting in April 1928 and the Racecourse Company went bankrupt soon after. Odder still, the Horse & Jockey appears on nineteenth-century maps, indicating that racing probably took place here in the 1800s. Today the Horse & Jockey is a friendly pub with a good choice of ales.

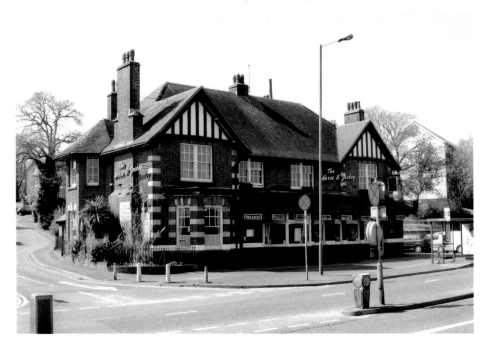

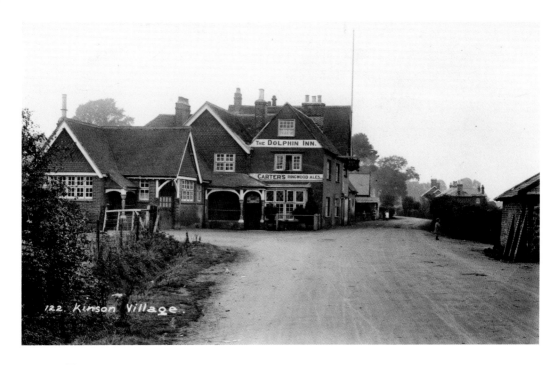

122. Kinson Village.

## Gullivers Tavern

Between 1903 and 1906 Charles Bennett was landlord of the Dolphin Inn at Kinson – another ex-Carters Brewery house. Also known as the Shapwick Express, he was the first British track & field Olympic champion. At the 1900 Paris Olympic Games he won gold at 1,500 metres and 5,000 metres. After the Dolphin, he returned to being a train driver. Imagine the contrast in adulation and riches today. In 1993 the pub was renamed Gullivers Tavern after its smuggling past. With its low-beamed ceilings it is easy to see why.

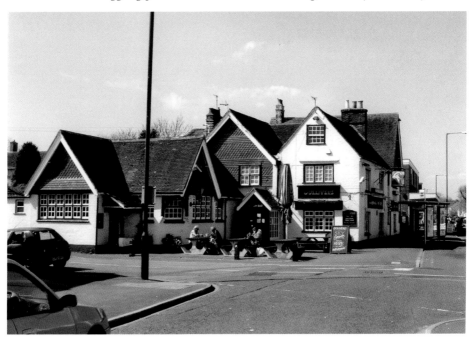

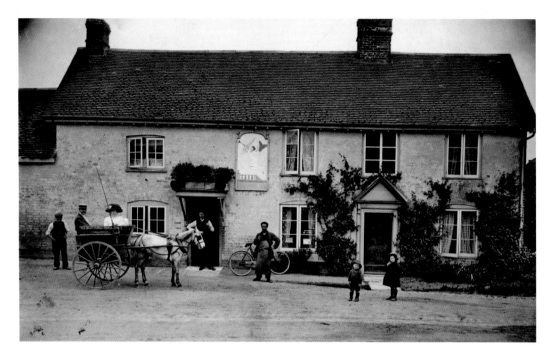

### Angel Inn

In this photograph, taken a century ago, landlord Thomas Reeks stands in the doorway of the Angel Inn at Longham watching children play in the street. The Angel in Ringwood Road was run by the Reeks family from 1910 to 1976. For much of that time there was no bar and drinks were poured from the cellar. Now the pub is in the ownership of Hall & Woodhouse and although opened up and greatly extended, there are booths and partitions to make the large interior seem more intimate.

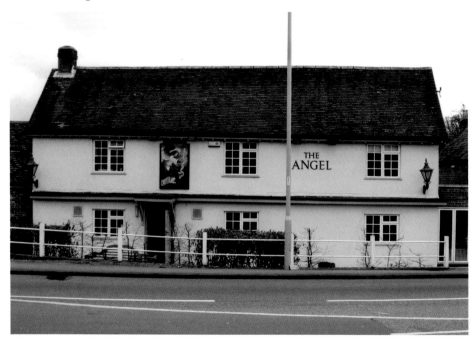

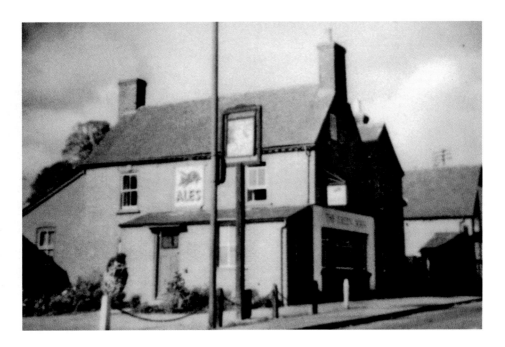

## Green Man

When coming into Wimborne from the west, the first sign of civilisation has long been the eighteenth-century Green Man, a very welcoming hostelry. Its name refers to a pagan fertility symbol and it is encouraging to know that over the years the inn has more than doubled in size. The pub has more recently become known for breathtaking floral displays that culminated in an appearance in the Britain in Bloom finals. The Green Man must also have green fingers!

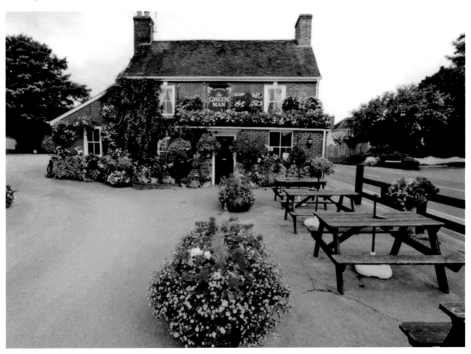

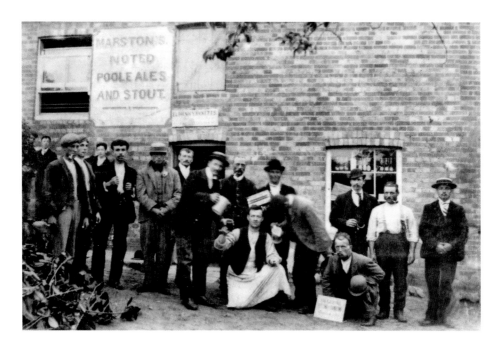

## Vine Inn

The Vine Inn at Pamphill, near Wimborne, remains one of the last truly unspoilt pubs left in Dorset. Occupying an idyllic setting, the pub nestles on a hillside beside a winding lane and overlooks rolling countryside. Three generations of the Ricketts family have provided first-class hospitality at the Vine for over a century, from when it started life as a cider and alehouse. Although the lounge bar is small and the public bar even smaller, this only adds to the character of this classic hostelry.

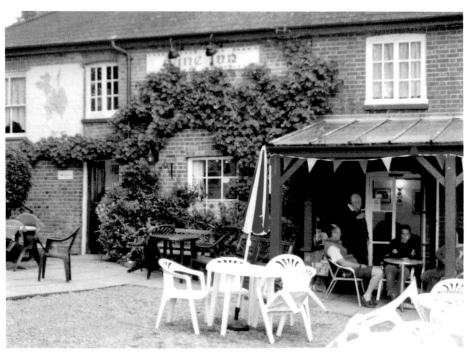

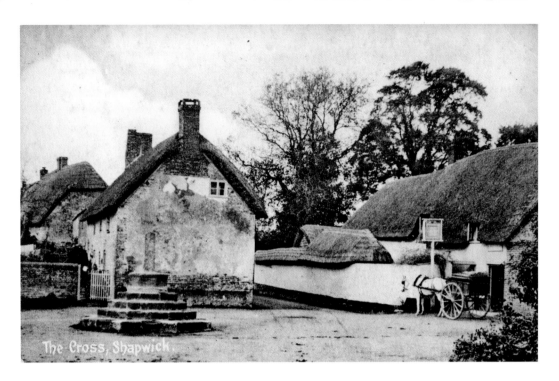

The Cross, Shapwick.

## Anchor Inn

It seems strange to come across a pub called the Anchor Inn at landlocked Shapwick, but before it silted up the River Stour reached its highest navigable point here. Having survived the fire that devastated much of the village in 1881, it appears the old thatched inn was replaced around 1920. Indeed, a 1920s Hall & Woodhouse guide describes the pub as 'recently rebuilt'. Fearing for the future of the Anchor, a co-operative of local people bought the pub in 2006 and thankfully saved it for the village.

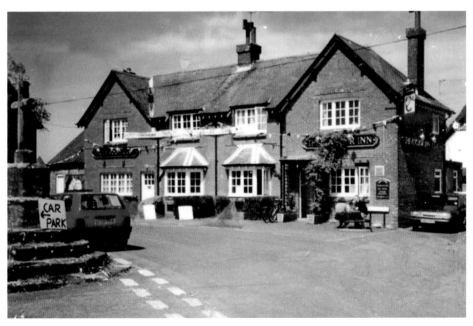

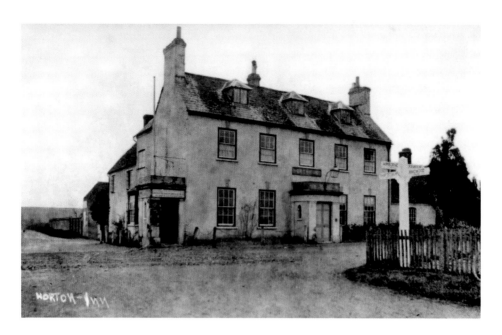

## Horton Inn

Once on the main London to Exeter stagecoach route, the Horton Inn at Horton Cross is now somewhat remote while still providing a focal point for the area. Although the front portico has gone (too close to the main road), the roadside bar remains. This was Thomas Hardy's Lornton Inn and 'the rendezvous of many a daring poacher for operations in the adjoining forest'. Visitors enjoying Marston's ales today are less likely to discuss poaching than walks in the local areas of outstanding natural beauty.

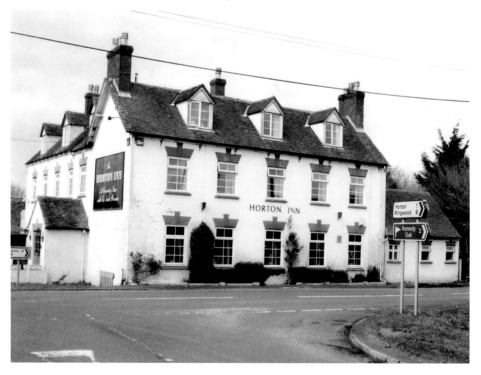

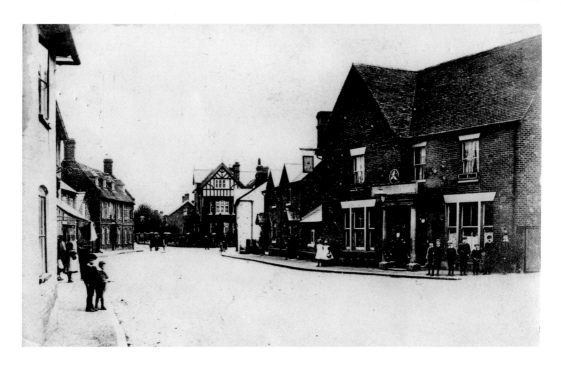

### Sheaf of Arrows

Cranborne is home to the Sheaf of Arrows, with thine hosts Rex and Karen Neville making it a most welcoming and friendly hostelry for locals and visitors. At one time a Strongs house, outbuildings behind the pub briefly housed the Cranborne Brewery in the mid-1990s. Now beers from the local Sixpenny Brewery are served. For the hiker who has roamed Cranborne Chase, working up a thirst and an appetite, the Sheaf of Arrows is highly recommended.

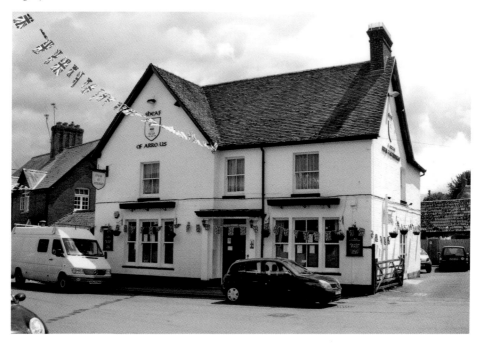

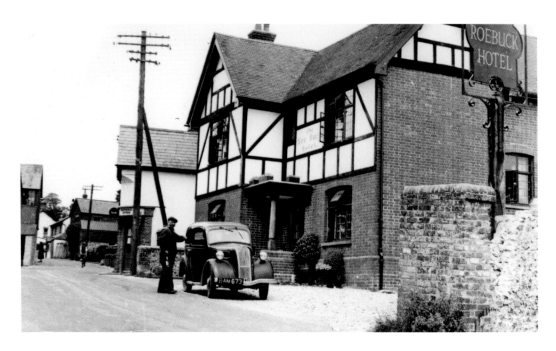

### Roebuck Inn

Two-thirds of the houses in Sixpenny Handley were destroyed by fire in 1892, including the old thatched Roebuck Inn. Edward Dutch was the landlord then and it is said he offered free beer to anyone who would help him put out the flames. The Roebuck was rebuilt in brick and tile and remains a comfortable country inn to this day. Just outside the village the award-winning Sixpenny Brewery flourishes and has a popular small tap that is now listed in the CAMRA *Good Beer Guide*.

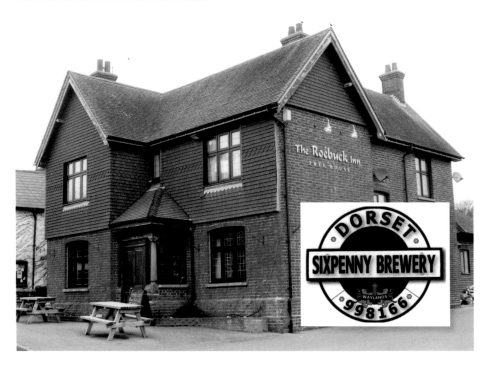

# Purbeck Area

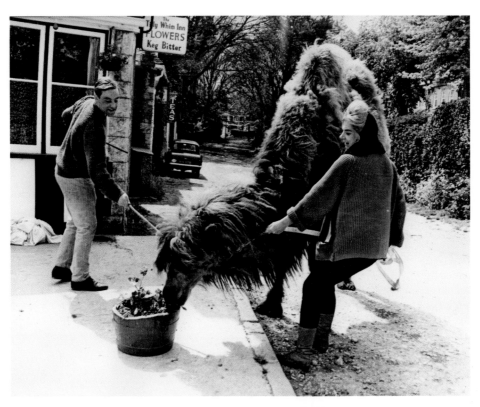

## Tilly Whim Inn

The Tilly Whim Inn was situated on the way to the Durlston Country Park. In the 1960s landlady Ruth Burridge purchased a Bactrian camel named Achmad for a publicity gimmick. Unfortunately Achmad ate everything in the beer garden! So the camel was sold and replaced by a brightly painted London taxi that would collect customers from the pier and offer a free shuttle service to and from the pub. Nowadays the Ship Inn at Swanage uses static advertising but definitely gets its message across.

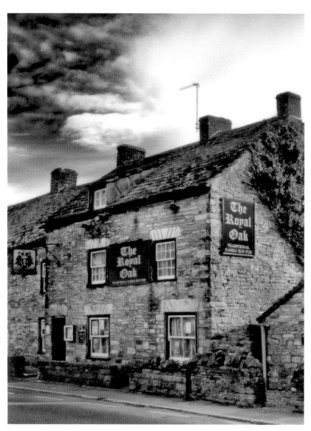

## Royal Oak

'The past is taking over the future' was a remark made by a customer when he was leaving the Royal Oak at Herston. This is echoed so many times by people who have met by accident or just appeared here. It is a meeting place for old and new friends who never forget their time here as they always are drawn back to this lovely little pub in the heart of Dorset. Time does not exist here – come in for minutes and stay for hours! Past, present and future customers are always welcome. (Caption courtesy of Rachel Aplin; lower photograph courtesy of Aaron Hardy)

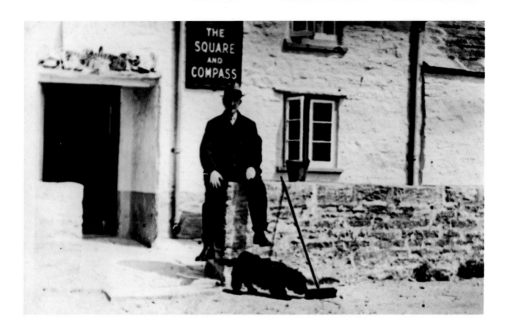

### Square & Compass

At Worth Matravers, the Square & Compass is one of the finest pubs on the South Coast. In 1907 'Old' Charlie Newman (above) took over the licence and purchased the original fixtures and fittings. Now Old Charlie's great-grandson, also called Charlie (below with Hugh), holds the licence – a continuous ownership by the Newman family. He still has some of the original fittings bought by his great-grandad. So what's new? It has electric lights not oil lamps, tap water instead of a well and flush lavatories.

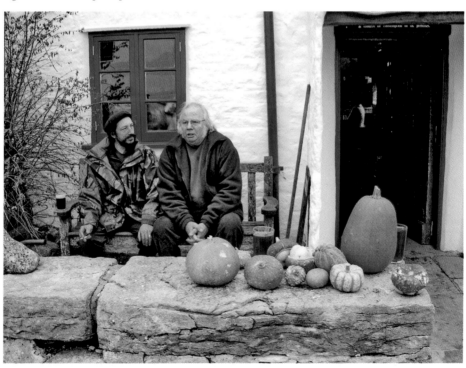

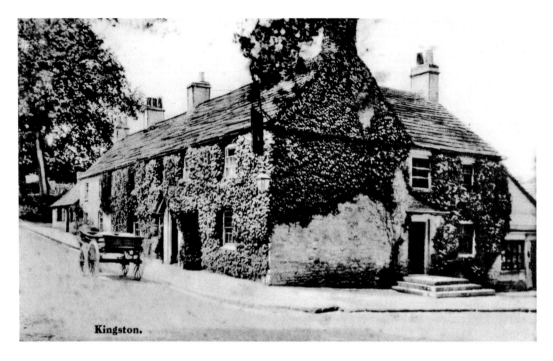

Kingston.

### Scott Arms

The Scott Arms at Kingston dates from 1787. Previously the New Inn, then Eldon Arms from the early nineteenth century, the pub became the Scott Arms after the Second World War. In the early 1960s the landlord, Mr Swan, was deaf and had a hearing aid that whistled. The louder the pub got, the more it whistled into the poor fellow's ear. His daughter Valerie opened the stable bar. It made a fine folk club, with entertainers playing on a minstrels gallery at the end of the bar.

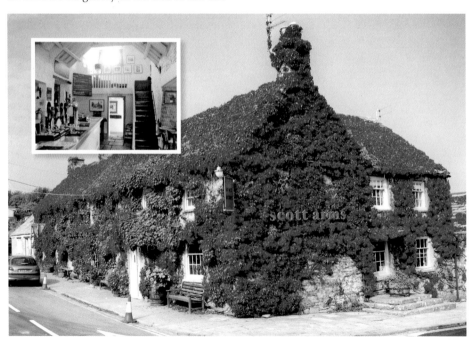

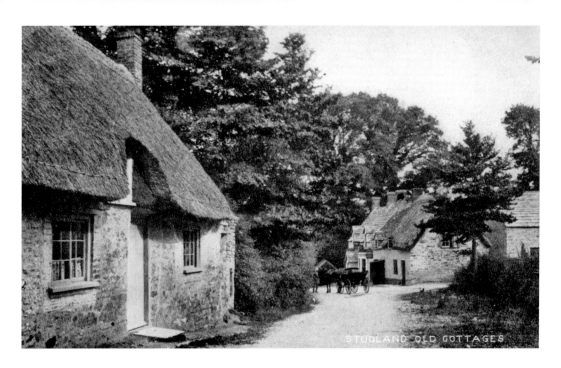

## Bankes Arms

In the late nineteenth century the quaint, old, thatched New Inn at Studland was rebuilt and renamed the Bankes Arms after the local landowning family. Over the years a stable bar to the rear was brought into use and hosted live folk music. The Lightbown family have owned the Bankes Arms since 1988 and have added a thriving microbrewery. The Isle of Purbeck Brewery's range of ales are available at the bar all year round and at the eagerly anticipated summer beer festival.

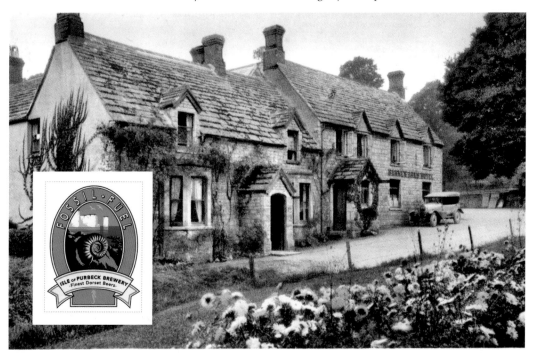

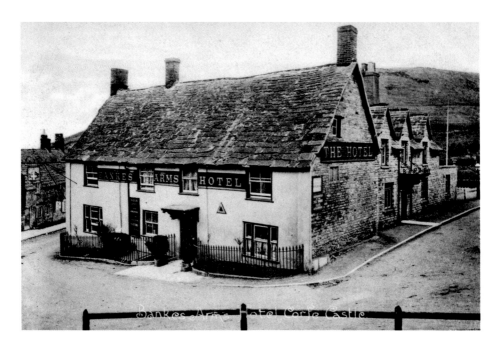

## Bankes Arms

During the late nineteenth century the Ship Inn at Corfe Castle was renamed the Bankes Arms as was the New Inn at Studland (see before). The Bankes at Corfe dates back to 1549, nearly a century before the destruction of the castle in 1646. With the public bar now an office, the hostelry concentrates on meals and has a pleasant beer garden overlooking the steam railway. Nearby, the Corfe Castle Brewery was established in 2011 and as yet largely supplies its four beers in bottles.

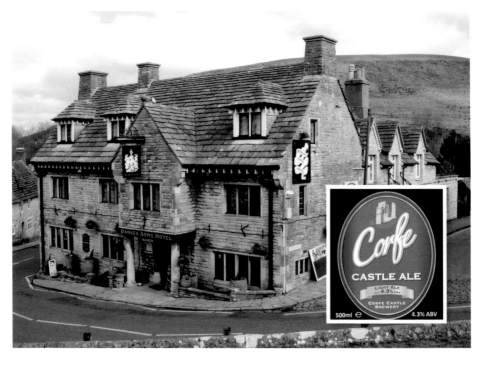

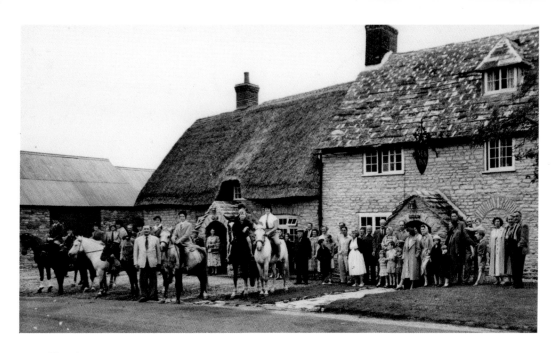

### New Inn

Standing impressively in a valley in the Purbeck Hills, the 400-year-old New Inn at Church Knowle was previously a farmhouse. It has been licensed for around half of its life and the Estop family has run it since 1985. The main bar to the left was originally the dairy and cheese barn. In 1996 the New Inn was destroyed by a thatch fire, but, with great resolve, the pub was reopened six months later. The Dorset Blue Vinny soup with a crusty bread roll and a pint of Dorset ale is a match made in heaven.

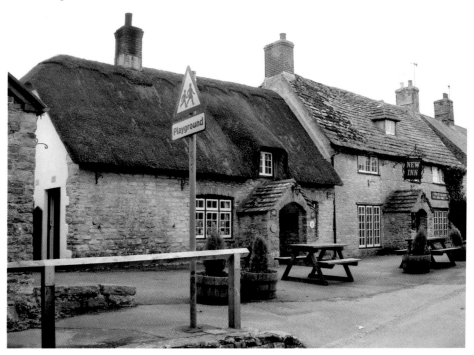

## Kings Arms

Cheers to the Kings Arms at Wareham, voted East Dorset CAMRA Pub of the Year 2012. In the Kings Arms backyard, Charles Kenway is heartily congratulated for earning the Queen's South Africa Medal in 1902. The original Kings Arms in South Street burnt down during the fire of Wareham in 1762. The present thatched building survived the flames and became a pub in 1820. Some 250 years later, pub regulars the Purbeck Independent Simpletons Society bravely tried to blow out the Olympic torch to prevent another fire.

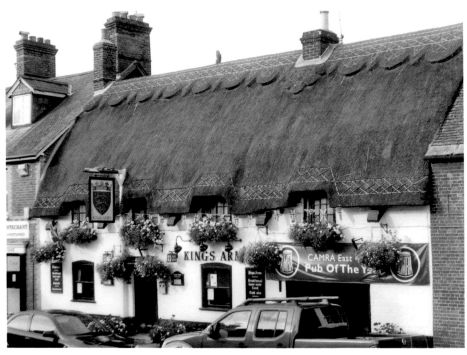

## Railway Tavern

At Northport, the Railway Hotel became the Railway Tavern in the early 1980s. Since 2001 it has been an Indian restaurant. Section 20 of the Local Government (Miscellaneous Provisions) Act 1976 formalised the requirement of sanitary provision in pubs, etc. Most followed the recommendations to upgrade their facilities and brought them indoors. In 1982 the Wareham Court Leet condemned the lavatories at the Railway and received the demolition contract. Sanity and sanitation took a hammering.

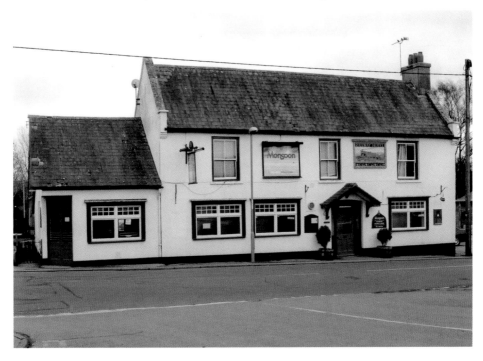

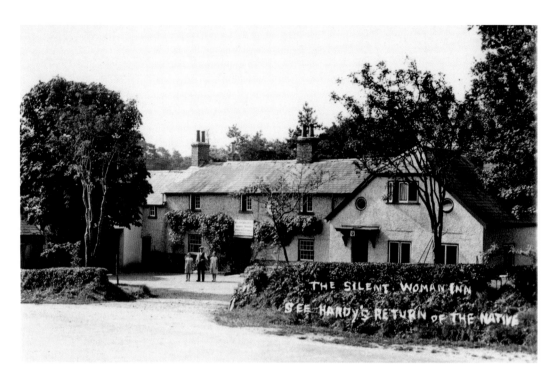

### Silent Woman Inn

Two miles north of Wareham, Richard and Denise Bell welcome all to the superb Silent Woman Inn at Coldharbour. Originally called 'The Inn at Coldharbour', it was licensed to accommodate a thirsty stipendiary priest whose route from Salisbury to Wareham took him past the door. During the eighteenth century it became the Angel Inn. It changed to the Silent Woman Inn after the death of Thomas Hardy, when a bright entrepreneur took advantage of it being the 'Quiet Woman' in Hardy's *The Return of the Native*.

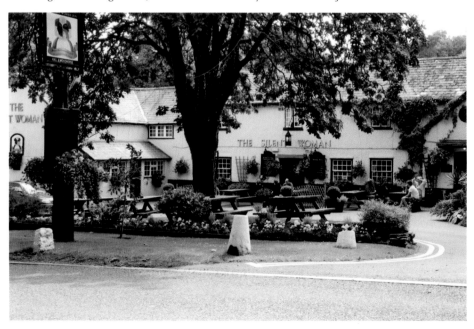

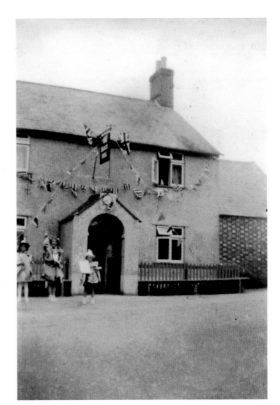

### Stokeford Inn

Established in the late 1800s, the Stokeford
Inn at East Stoke has only recently
changed its name from the Black Dog. It
stands roadside and is a homely family-run
free house. Unusually for a pub nowadays
it retains two bars. A century ago the
Basket family were landlords of the Black
Dog for several decades. Eileen Hardy
(whose mother took over running the pub
in 1933) recalls her mother telling her
about Lawrence of Arabia drinking there
when he lived at Clouds Hill.

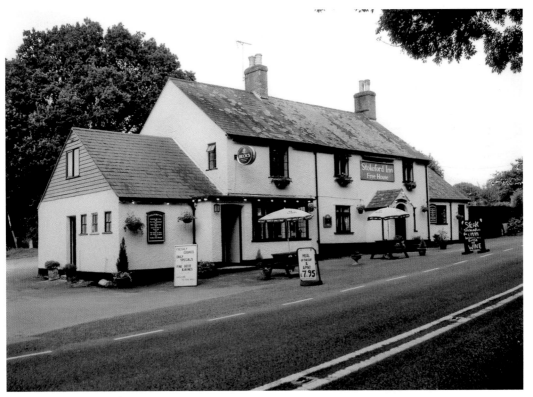

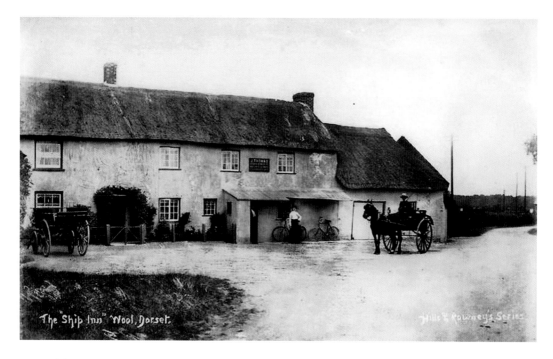

The "Ship Inn" Wool, Dorset.

Hills & Rowney's Series

## Ship Inn

Almost 200 years ago the Ship Inn at Wool was known as 'Lucas' Lugger' as the landlord Thomas Lucas ran a smuggling operation from the inn. A report of 1827 openly called the Ship a 'public house and general rendezvous for smugglers'. Wind forward to the 1960s and the pub had a gentlemen's happy hour on Sunday lunchtimes, which included a female stripper. In 2012, Hall & Woodhouse gave the Ship a major internal refurbishment and an outside television screen for the smokers.

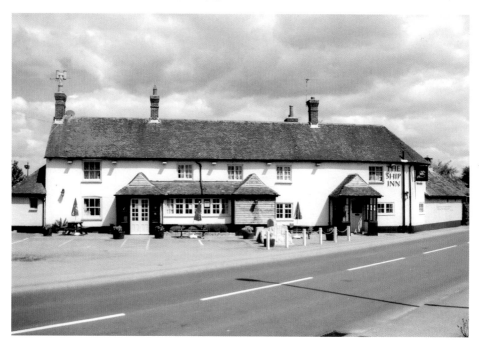

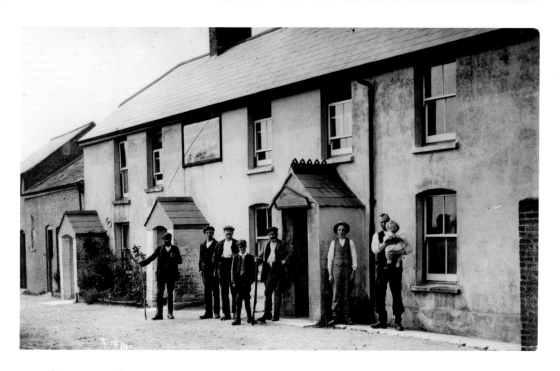

### Countryman Inn

The Countryman Inn at East Knighton was formerly called the Rising Sun. About 100 years ago the landlord was Jesse Blandamer. He told his grandson about Lawrence of Arabia who used to drink at the inn. If Jesse felt that Lawrence would be unsafe to ride his motorcycle to Bovington, he used to lock the bike in the coach-house and arrange for a taxi to take Lawrence back to camp. Today Lawrence's favoured seat survives at the Countryman, which still has a friendly, relaxed atmosphere.

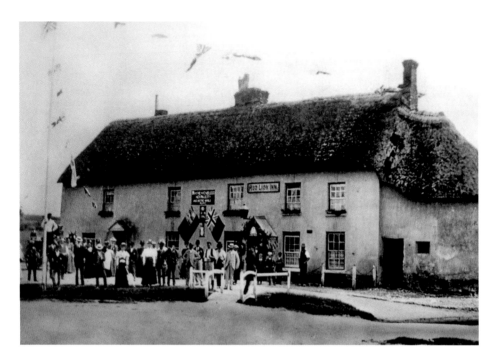

### Red Lion

The photographs of the Red Lion at Winfrith Newburgh are 115 years apart, with villagers celebrating their respective Queens' Diamond Jubilees. Between these events the inn has endured two enforced changes, twice losing its thatched roof to fire. The thick walls were more resilient and are incorporated into the renovated pub, which now has a tiled roof. After the last fire the interior was replaced in the traditional style which makes for a welcoming pub with comfortable dining areas and a good bar.

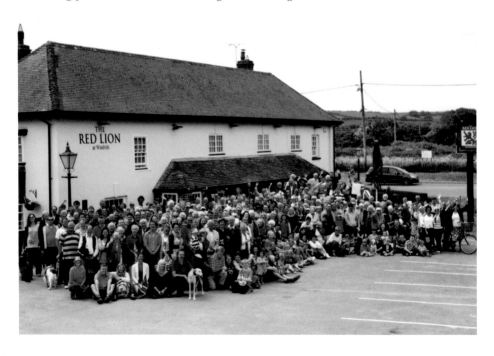

# Blandford to Gillingham

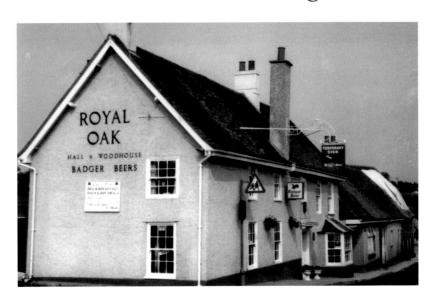

## Royal Oak

It is heartening to see the family-friendly Royal Oak in Milborne St Andrew at the centre of village life again. The pub was closed in 2008, but with community support new licensees Andrew and Sarah Fox reopened the doors in September 2009, much to the delight of the locals. The Royal Oak now serves beer from newcomers the Sunny Republic Brewing Co. The brewery at Winterborne Kingston was launched in 2012 with adventurous ales such as Beach Blonde and Huna Red.

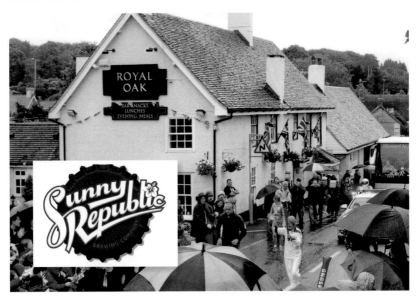

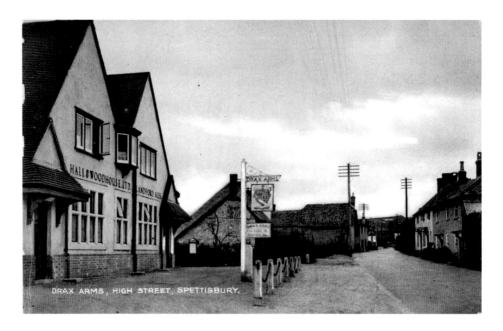

DRAX ARMS, HIGH STREET, SPETTISBURY.

## Woodpecker

The Woodpecker at Spetisbury was for years known as the Drax Arms. Around 1920, Hall & Woodhouse purchased the inn from local landowners, the Drax Estate. Soon after, in 1926, the pub was rebuilt after the original thatched inn was destroyed by fire. Then in 2009 the brewery put the pub on the market. The new owner discovered that Spetisbury derived from the Old English word *speht*, meaning woodpecker, hence the change of name. A fine selection of ales is served, many from small local breweries.

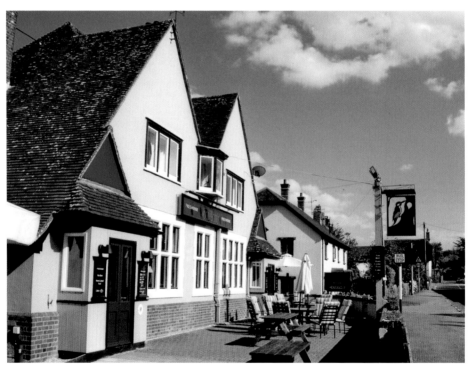

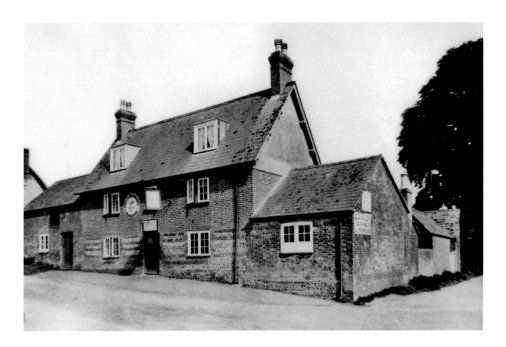

### True Lovers Knot

At Tarrant Keynston, the True Lovers Knot is a fine Hall & Woodhouse traditional country pub that retains some old world charm. The generous grounds contain a campsite and a children's play area to encourage family visits. There are two explanations for the pub's name. Firstly, that long ago a romance between the landlord's son and local landowner's daughter ended in tragedy with three hangings. The other more likely explanation is that the name represents a two-looped bow exchanged by lovers in earlier times.

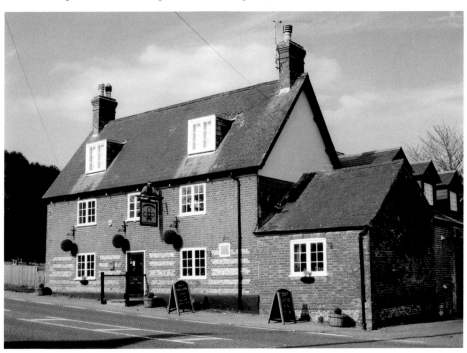

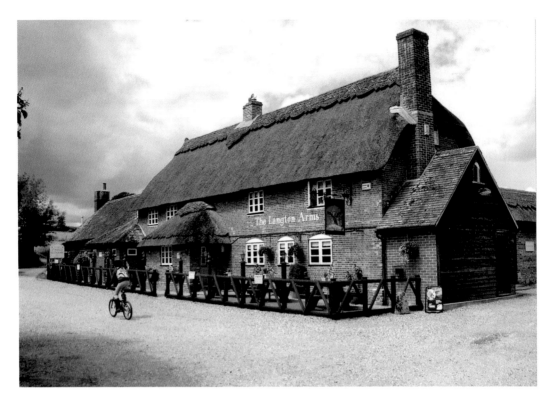

## Langton Arms

Since the closure of the Bugle Horn Inn at Tarrant Gunville around 15 years ago, locals have headed a couple of miles south to the Langton Arms at Tarrant Monkton. Then disaster struck when the seventeenth-century rural inn was badly damaged by fire in 2004. Thankfully the pub was sympathetically restored and continues to serve a wide area. A few decades ago draught milk was available over the bar, but over the years the Langton Arms has evolved into a country dining pub in an idyllic setting.

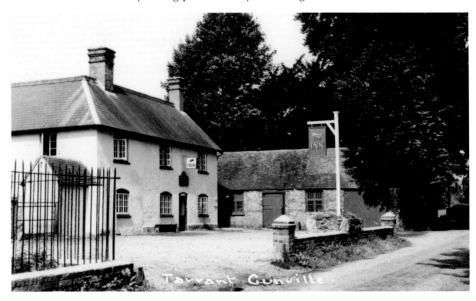

### The Dolphin

An inn named the White Bear first appeared on this site in East Street after the Great Fire of Blandford in 1731. Around 1840 its name was changed to the Star Inn but after 150 years of serving ale, the Star was closed. A short hop across the road, The Dolphin survives and thrives as a tap for the Dorset Piddle Brewery. The brewery has rejuvenated the pub into an atmospheric town-centre alehouse that offers their full Piddle range along with carefully selected guest beers. Think before you ask for a sample!

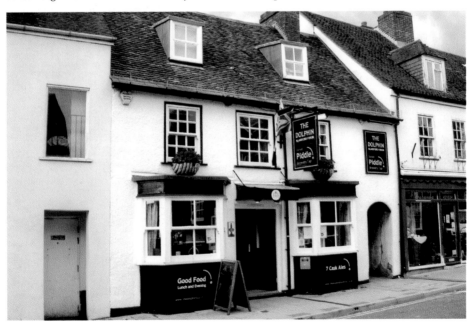

## Stour Inn

Just around the corner from the Hall & Woodhouse Brewery in Blandford St Mary, the Stour Inn is effectively the tap and helps reduce the brewery's ale miles. Originally called the New Inn, the 400-year-old hostelry is very much a community-centred pub. It has a cosy traditional interior and a well kept 'secret garden' which amazingly is visited by Father Christmas. Along with the great range of Hall & Woodhouse ales, an extensive selection of traditional pub games are enjoyed at the inn.

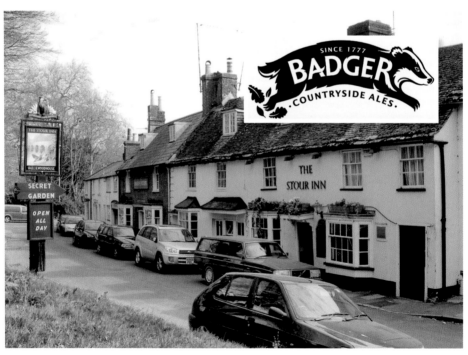

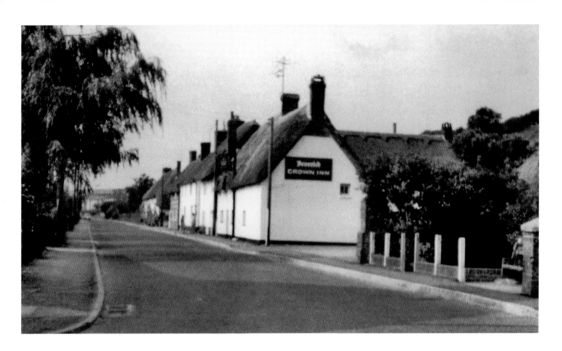

## Crown Inn

In Winterborne Stickland, the Crown Inn really engages with the locals. There are menu development nights when villagers put forward suggestions, at some events local traders set up stalls in the car park, and there is live music at weekends. Back in the late 1950s the Crown had a regular who used to tap on the table as if playing an imaginary piano. One night the somewhat infamous and emotional landlord cuffed him round the head and said, 'I've told you before, we ain't got a music licence'.

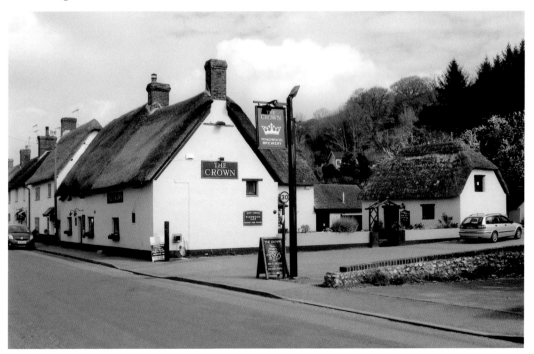

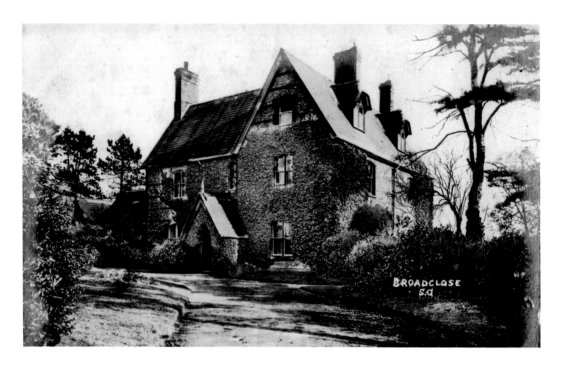

## Fox Inn

An unfortunate casualty to fire, the old Fox Inn on The Knapp at Ansty burnt down in 1915. Among the properties owned by brewers Hall & Woodhouse at Ansty was Broad Close, home to the Woodhouse family in the nineteenth century. Indeed several of the Directors of the company were born there. The licence was transferred to Broad Close and the property converted into the new Fox Inn. Since then the Fox has been greatly extended by the brewery and remains a very comfortable country inn.

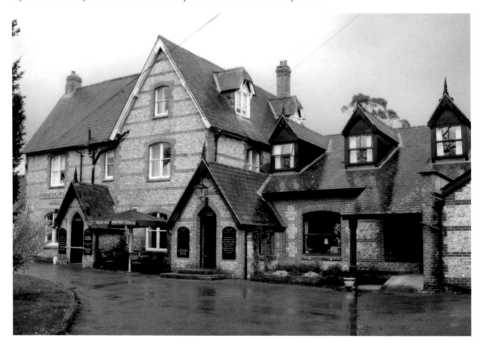

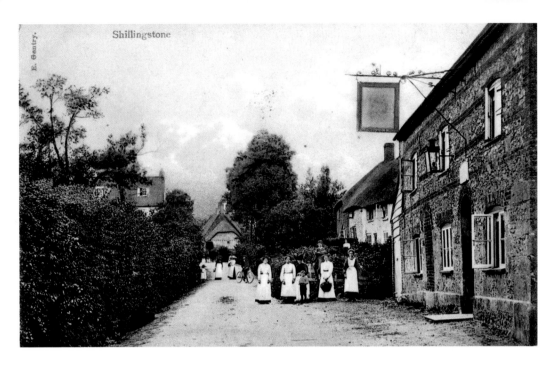

### Old Ox Inn

The Old Ox Inn at Shillingstone has seen the New Ox Inn come and go. The New Ox is now a soft furnishings shop called Feathered Nest and its angled doorway is just visible below left. Once an Eldridge Pope pub, the Old Ox is now a free house in the safe hands of Garry and Gillie Pickering. They have worked hard to re-establish the pub at the centre of the community and have repainted the exterior in black and white in the tradition of the whitewashed Dorset inn.

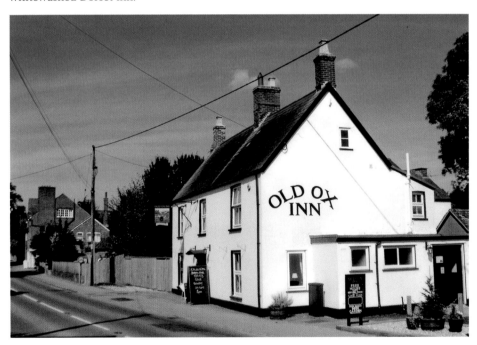

## Royal Oak

Like so many villages, Okeford Fitzpaine now has only one pub, the traditional and welcoming Royal Oak. When the New Inn closed in 1960, its skittle alley was transferred to the Royal Oak. In the mid-1960s a group of local steam enthusiasts met in the alley to organise a 'Working of Steam' event. The first steam show was held at Stourpaine in 1968, which now has grown into The Great Dorset Steam Fair, the largest and most spectacular event of its kind in the world.

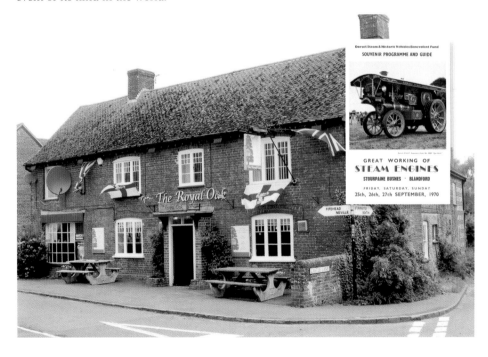

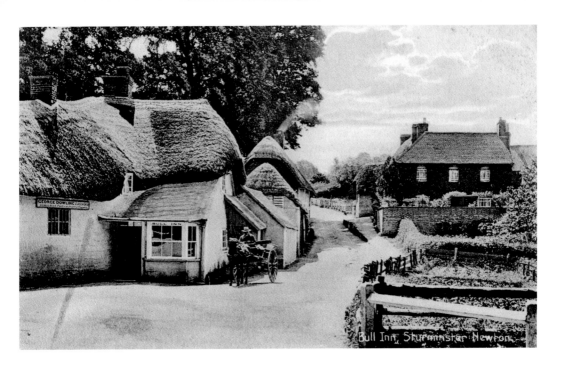

## Bull Tavern

Sturminster Newton is the home of the Bull Tavern, an old thatched Hall & Woodhouse pub that is full of character. It is easy to imagine farmers of days gone by making their way back from market and stopping for refreshment at the Bull. A verse by the wooden statue sums it up: 'Welcome Ye! To Sturminster Newton, The Heart Of The Blackmore Vale, Come To Ye Olde Bull Tavern, Take Up Thy Glass Of Real Dorsetshire Ale.'

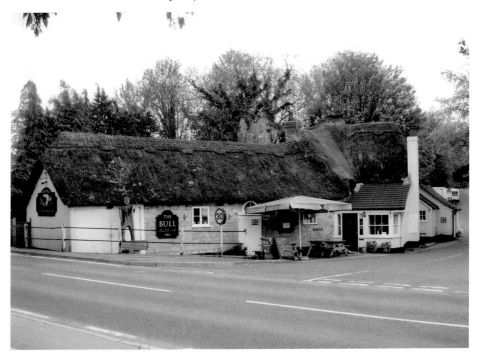

### The Talbot Inn

From 1876 at Iwerne Minster, the Glyn family started rebuilding their estate cottages in brick. This continued from 1908 under new owner James Ismay, who was also a Director of the White Star Line. The Talbot Inn was originally the estate manager's house and stables for the rebuilt Manor. Its inn sign shows an unusual black Talbot dog, the crest of previous Lords of the Manor, the Bower family. So the Talbot is a relatively new hostelry in Dorset terms, but with a lot of history.

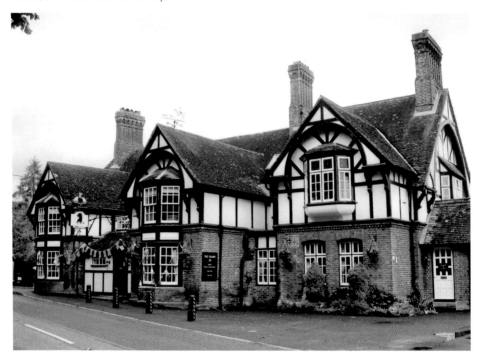

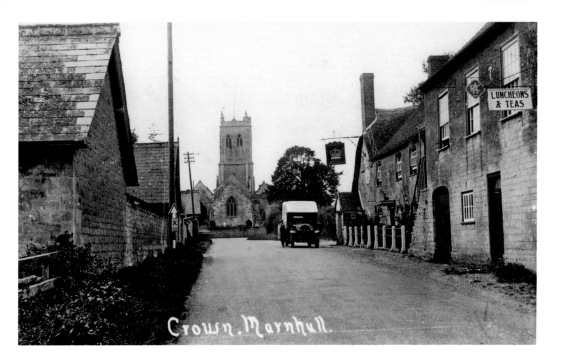

## Crown Inn

The Crown Inn at Marnhull is a gem in Hall & Woodhouse's estate. Retaining many original features, the pub is also the local for villager Archie Tulk. He has been a regular since 1930 and in 2004 was promised a pint of beer a day by the brewery as a reward for his loyalty. Eight years on and Archie is still enjoying his complimentary tipple. The Crown also hosts the organisers of the annual Marnhull Soapbox Derby – a daring gravity go-kart grand prix. Strangebrew 1 was the 2012 champion.

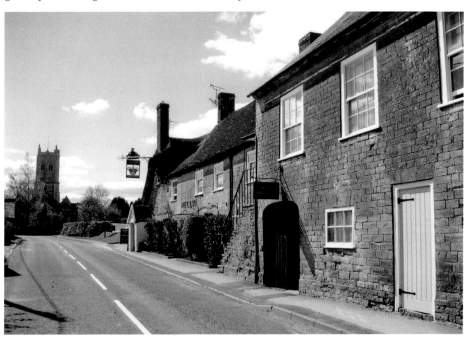

## Mitre Inn

Looking up Shaftesbury High Street, on the right the Crown Inn used to be a good old locals pub. Now it is closed and facing an uncertain future. The bar was on the left of a central passageway and to the right used to be a betting shop – not a recommended combination! Further up the High Street, on the left, the Mitre Inn continues to serve good beer in superior surroundings. Like most pubs, the interior has been remodelled but the Mitre remains an elegant hostelry.

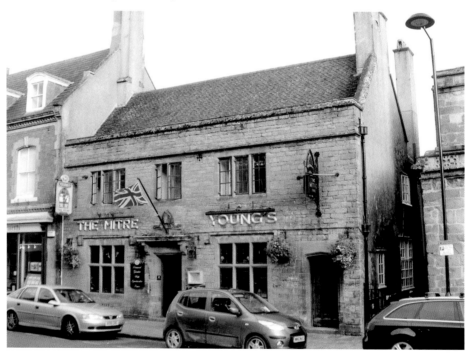

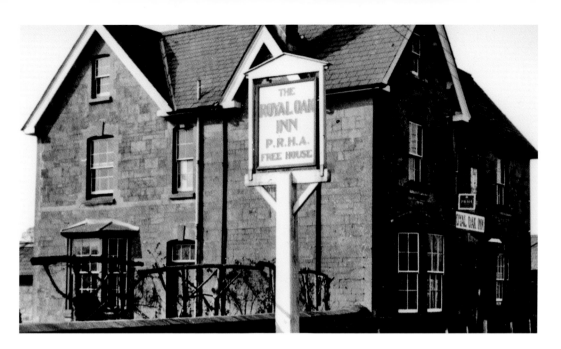

## Coppleridge Inn

The Royal Oak at Motcombe was a rarity 70 years ago as it was one of only six pubs in Dorset run by the PRHA (Peoples Refreshment House Association). Their pubs sold alcoholic beverages but landlords were given bonuses dependant on food and non-alcoholic drink sales. The Royal Oak has closed but up the hill is the Coppleridge Inn. The bar adjoins a restored eighteenth-century farmhouse and a selection of ales can be quaffed in very pleasant surroundings. (Top photograph courtesy of Barrie Pictures)

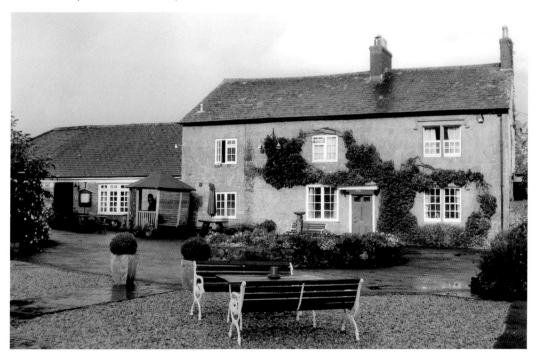

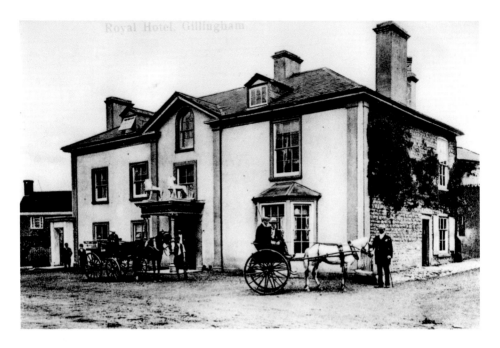

## Red Lion

Since the once grand Royal Hotel in Newbury was demolished, ex-regulars can nip to the Red Lion. First recorded at Gillingham in the 1690s, going inside is like stepping back in time. Unusually the landlord has stopped doing meals as he wanted to return to traditional pub values. In 2010 the Red Lion won the Hall & Woodhouse Best Community Pub of the Year award. Nearby, award-winning nanobrewery Small Paul's continues to produce delicious Dorset ales. (Top photograph courtesy of Barrie Pictures)

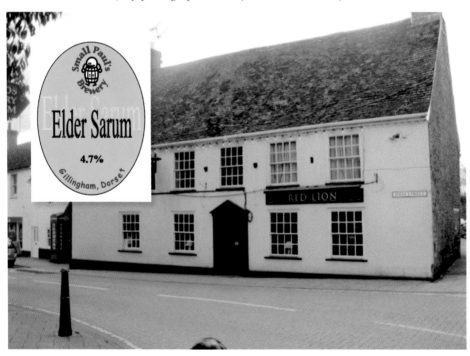

# Portland & Weymouth Area

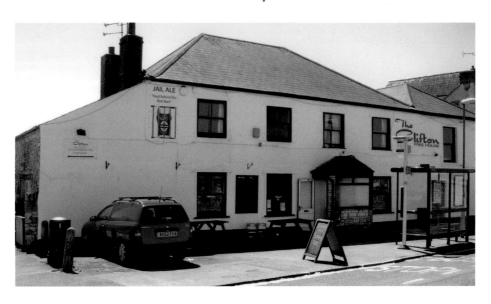

### The Clifton

The Clifton is a free house at Easton on Portland, which to some is the Isle of Capri of Dorset. Not long ago there were dozens of pubs on Portland, and thankfully the old Clifton Hotel is among the survivors. Welcoming to regulars and visitors alike, the pub has much to offer, such as bar games, skittles and live music. It also provides refreshment to Portland United Football Club. An aquarium within a frame helps decorate the bar along with a sign saying 'Keep Portland Weird'.

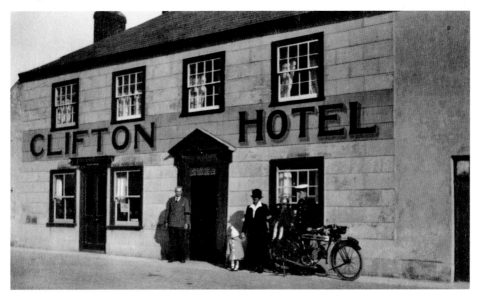

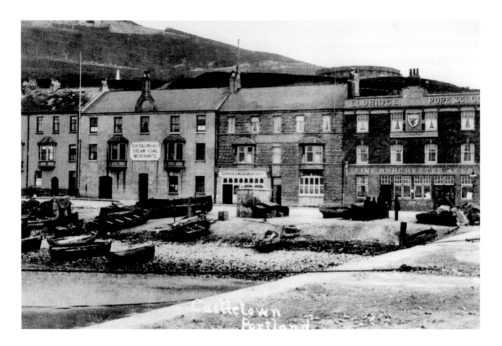

## Green Shutters

With the Portland Dockyard gates a stone's throw away, the Albert at Castletown was an Eldridge Pope pub providing relief for thirsty sailors. Next door, the Sailors Return (then owned by Groves Brewery) hit the rocks over a decade ago. The Navy has gone, but renamed the Green Shutters the pub now hosts Gold Medal sailors. Ben Ainslie was interviewed outside by the BBC after his amazing performance in the 2012 Olympics. Cheers, well done Ben! (Top photograph courtesy of Barrie Pictures)

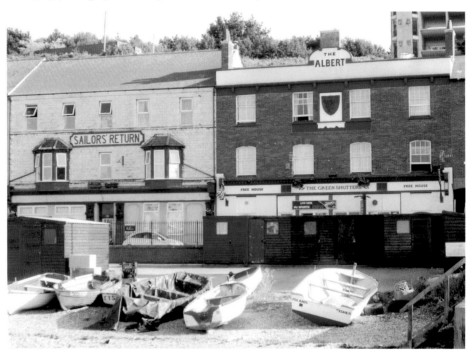

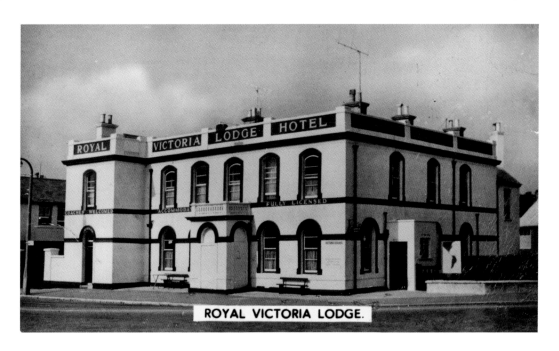

ROYAL VICTORIA LODGE.

## Royal Victoria Lodge

Standing proudly again in Victoria Square at the entrance to Portland, the Royal Victoria Lodge has been reopened and rejuvenated by the Naylor family. Used as a naval hospital in the Second World War, its fortunes flagged despite a change of name to the Masons & Mariners. Reverting to its original name, the current tenants are repairing the fabric of the building and restoring the pub's reputation. When the Olympic Sailing Village (built directly behind) is used for housing, new locals will be welcome here.

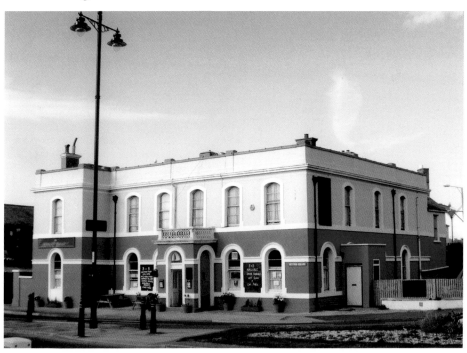

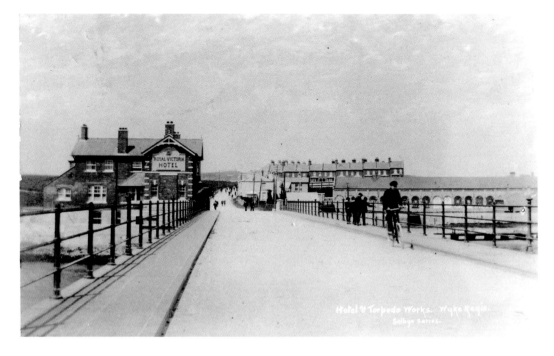

### Ferrybridge Inn

On a very windy and rainy evening on 12 July 2012, locals cheered the Olympic torch past the Ferrybridge Inn at Wyke Regis on its way to the National Sailing Academy. Previously named the Royal Victoria Hotel, it overlooked the Whitehead Torpedo Factory for over a century until 1997. Now in a more leisure-focused environment, the Ferrybridge Inn offers a warm welcome with excellent ales from the ever-popular Dorset Brewing Company. The inn also accommodates a diving school called Fathom & Blues.

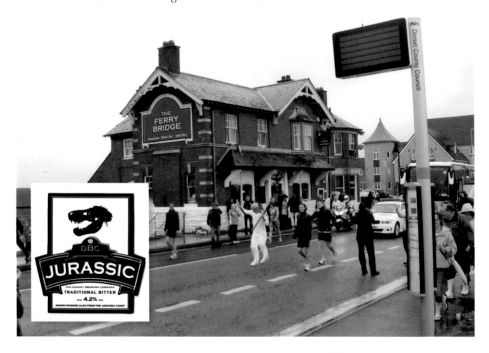

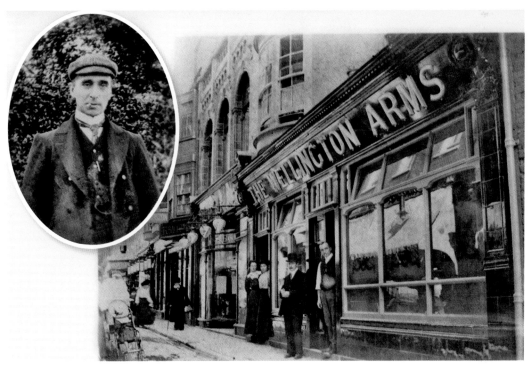

### Wellington Arms

Unfortunately it seems no one recognises the Edwardian landlord of the Wellington Arms in St Alban Street, Weymouth. He could be Daniel Rolls (1896–1903), James Harvey (1903–07) or Robert Loveridge (1907–22). When the Navy was in town, sailors came in droves to this excellent traditional pub and threw their hats in a pile in the corner. Apparently the hats mostly found their owners at the other end of the night. Now it's hats off again to the wonderful 'Wellie'.

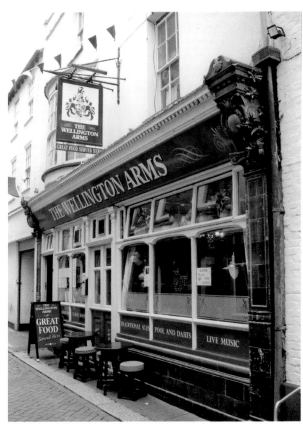

# Black Dog Hotel

(Prop.: Mr. and Mrs. H. Wardell)

## ST. MARY STREET, WEYMOUTH

Phone 437

**HISTORIC XVIth CENTURY INN**

## The Black Dog Inn

Between Barclays bank and Marks & Spencer at the top of St Mary Street, there lurks an infamous survivor. Parts of the Black Dog Inn are over 500 years old and it has a long and dark past. Around the time of the Civil War, a rich guest was murdered by the landlord, who then counted his new wealth on a table by the front window. Smugglers used The Black Dog as a base for centuries. Daniel Defoe was supposedly inspired to write *Robinson Crusoe* after hearing salty tales at the inn.

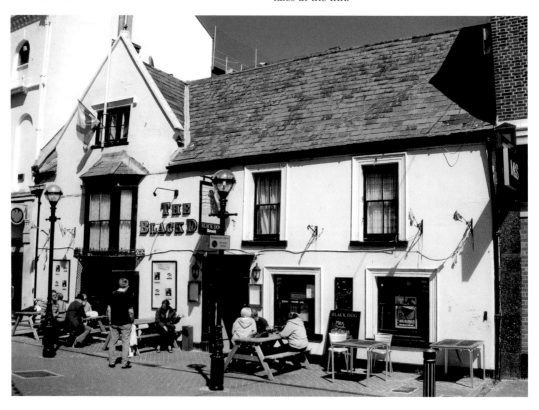

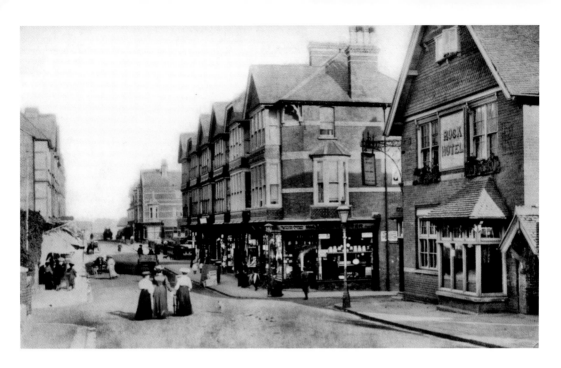

## Rock Hotel

In the new photograph of the Rock Hotel in Westham, Weymouth, a large tiled 'JG' monogram is just visible under the gable apex. Together with a faded painted sign below, these are the only surviving livery on Weymouth pubs of the old John Groves Brewery in Hope Square. The hotel itself has had to change with the times to stay open. The upper floors have been converted to flats and the extended ground floor has the atmosphere of a relaxed café bar, which happily serves good beer.

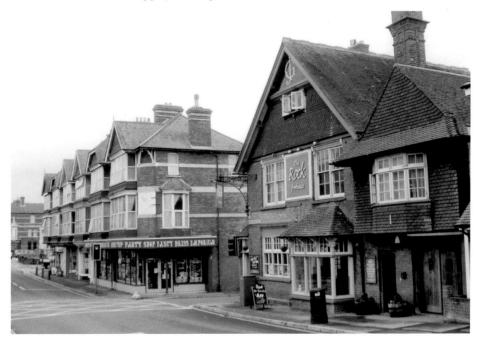

## The Alex

Behind the modest exterior of the Alex (previously Alexandra Inn) at Charlestown you can find the true essence of a traditional British pub. Your hosts Sharon and Don Pearce, who have had thirty years in the trade, make you feel welcome as soon as you enter. It's the sort of atmosphere you cannot buy. Sharon the landlady also does the catering. Don plays in one of the three darts teams and there is always some good humoured banter between them and their many loyal regulars of all ages.

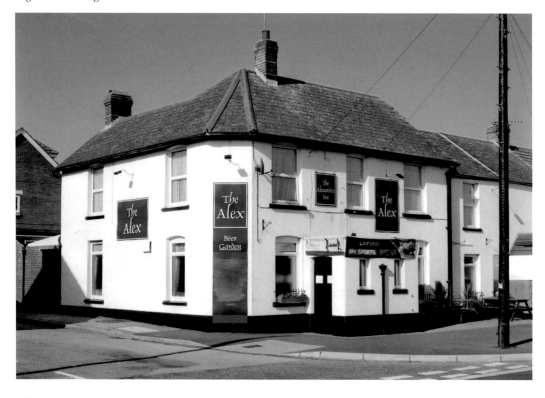

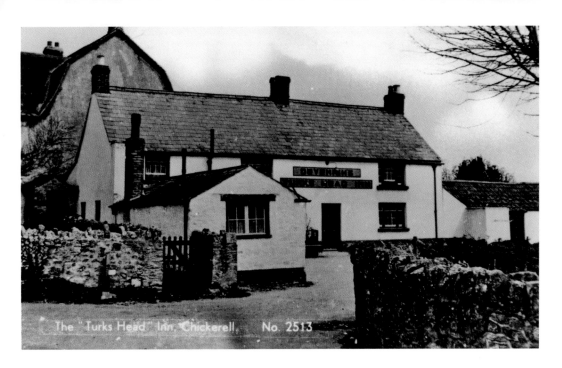

The "Turks Head" Inn, Chickerell. No. 2513

### Turk's Head Inn

The Turk's Head Inn at Chickerell started life as a small rural beerhouse with stables, but as the village grew so did the pub. In the 1950s the landlord kept pigs in a sty where the car park is today. Around that time the inn supported eight skittle teams, four darts teams and two crib teams. Since then the skittle alley has been converted into a dining room and function area, with ramps to aid access. The Turk's Head has come a long way since its humble beginnings.

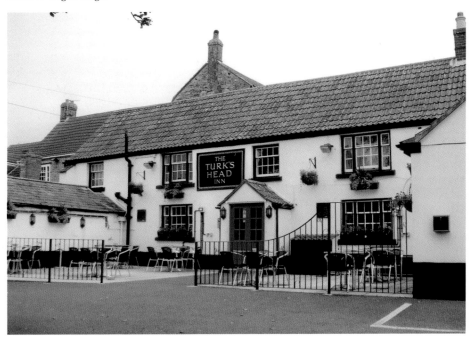

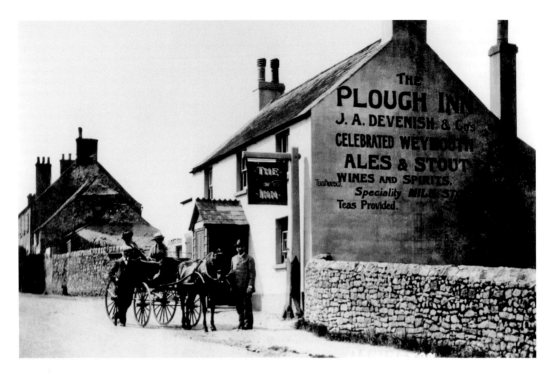

### The Sunray

Over thirty years ago the village of Osmington had two pubs. At the top of the hill was the Plough Inn, a spit & sawdust, men-only pub. The Plough closed in 1981. The Sunray was opened in the early 1930s and has expanded greatly over the years, with mirrors inside cleverly making it seem even bigger. In the 1960s they had a stable bar that was used as a folk club. It is hoped that the bar (seen on the right in the modern image) will reopen after refurbishment. (Top photograph courtesy of Barrie Pictures)

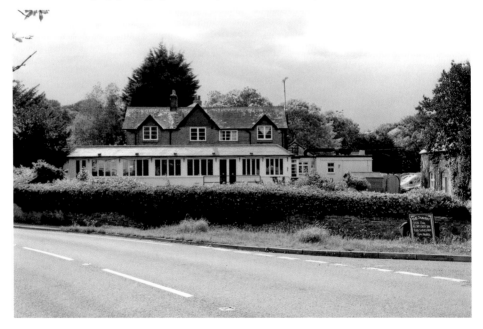

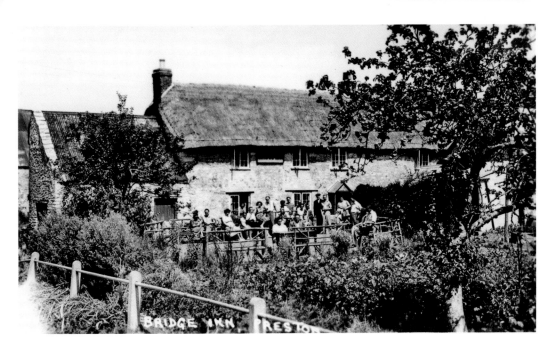

### Bridge Inn

Beware, or you will miss the small turning on the A353 for the Bridge Inn at Preston. Tucked away to the north of the main road, the 200-year-old pub was called the Swan Inn until 1936. Today a tiled roof has replaced the thatch and, like so many pubs, it has doubled in size. The homely bar remains separate from the restaurant area and includes a dartboard with an electronic scorer. In the 1960s brainpower was enough but these days everything seems to be getting easier!

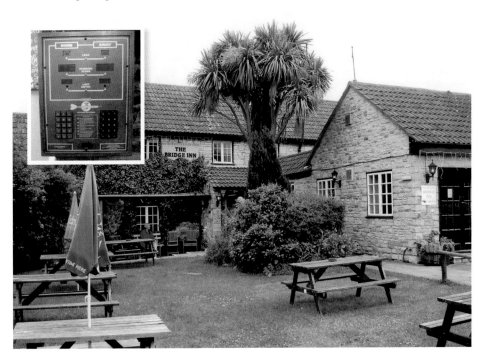

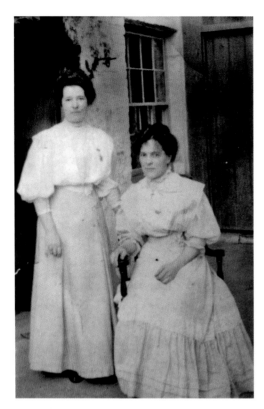

### Royal Standard

It wouldn't have happened in Alice and Teresa Langford's day. Unusually, the two sisters ran the Royal Standard at Upwey from 1903 to 1914. They kept it up together and the inn flourished. Sadly, a century later the pub was in decline. Enter landlord Phil Anderson, who has helped transform the fortunes of the Royal Standard. A microbrewery was installed to the rear and produces their excellent DT ales. Now the pub is buzzing again and the popularity of DT3 and DT4 is spreading.

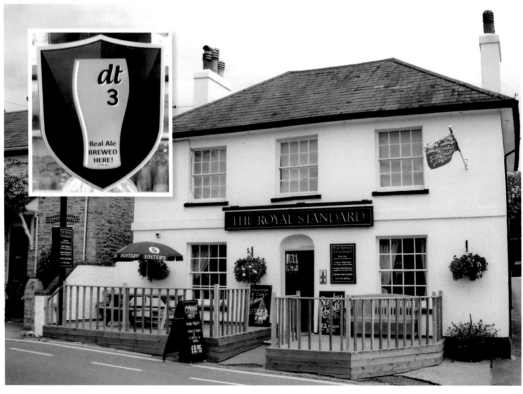

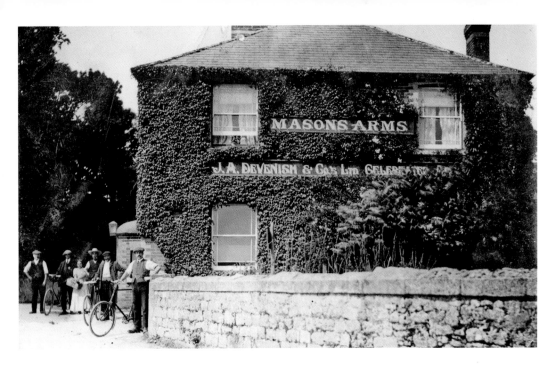

### Riverhouse Inn

Described in an old Devenish brewery guide as the 'answer to all those who wished for a glass of Devenish beer at the nearby Upwey Wishing Well', the Masons Arms is a classic example of how a hostelry has had to adapt to survive. As the rural population has changed, the Masons Arms has been transformed into the Riverhouse Inn. The reborn inn is a self-proclaimed family-run gastropub restaurant specialising in Mediterranean and English cuisine – the answer to modern-day wishes.

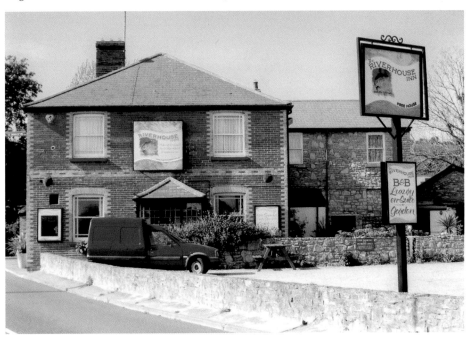

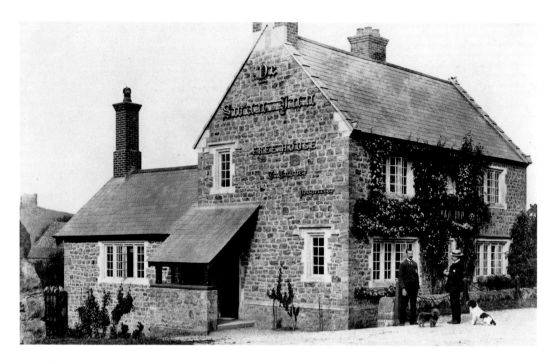

### Swan Inn

As a young farm worker, Graham Roper had always enjoyed the Swan Inn at Abbotsbury so he asked Devenish Brewery to consider him for a tenancy whenever a vacancy arose. On Monday 7 November 1966 the landlady for the previous thirty years passed away. As there were no relief managers available, the brewery offered the pub to Graham, providing he could start that Friday 11 November. He has been there ever since. 'Yer, prob'ly the longest serving landlord in Darzet.'

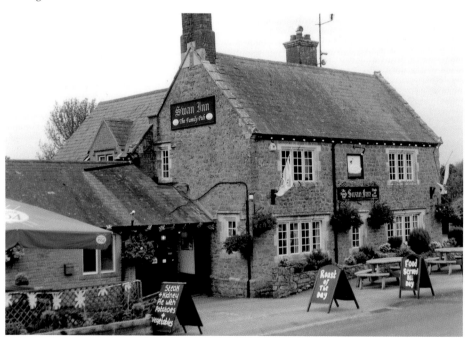

# Dorchester to Sherborne

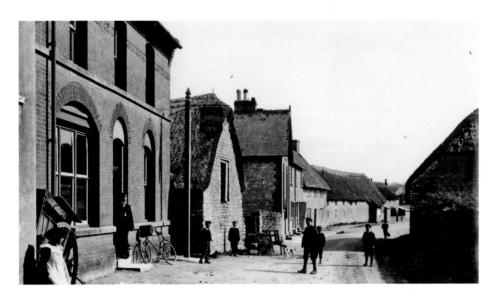

## Black Dog

Above left, the Compasses Inn at Broadmayne closed during the 1970s. This was a shame for folk music followers as it had wonderful acoustics due to its high ceilings. Opposite and down the road, the Black Dog survives but has seen several changes of landlords over the last few years. The present team of Stephen, Becky and Michael are working hard in tough trading conditions to keep the pub at the forefront of village life. This is a great pub – keep up the hard work.

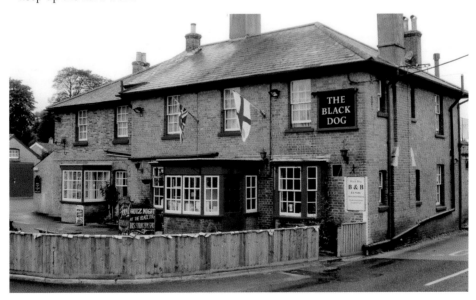

### Wise Man Inn

Previously a Devenish house, the Wise Man Inn at West Stafford has been popular since it began life as a hostelry in 1938. This probably has something to do with the building itself being 400 years old. However, tragedy struck in 2006 when the inn was destroyed by fire. It must have been a very wise man who made the decision to rebuild it, and in 2008 the doors opened again. Today the pub promotes itself as 'a traditional village pub meets rural gastro cuisine'.

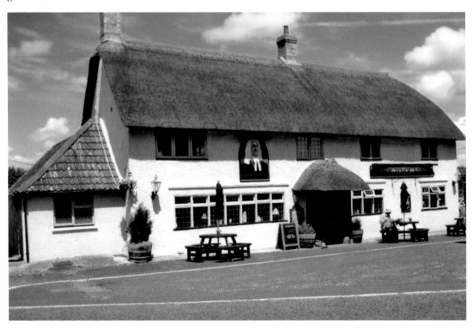

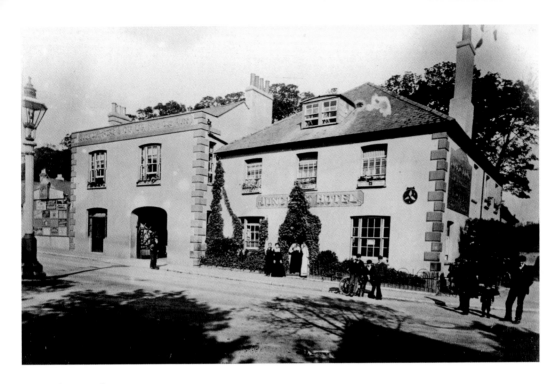

### The Junction

The Junction Hotel, now the Junction, holds an enviable position on Great Western Road at one of Dorchester's important crossroads. It is just a barrel roll away from the old Eldridge Pope Brewery in Weymouth Avenue too. The original eighteenth-century building, already an impressive coaching inn, was extended in late Victorian times to the left. Now a Marston's house, the large bar serves an impressive range of ales to Dorchester market traders, shoppers and tourists.

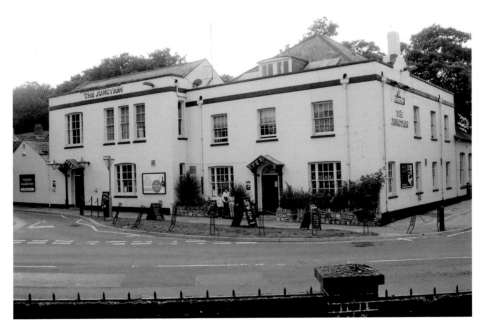

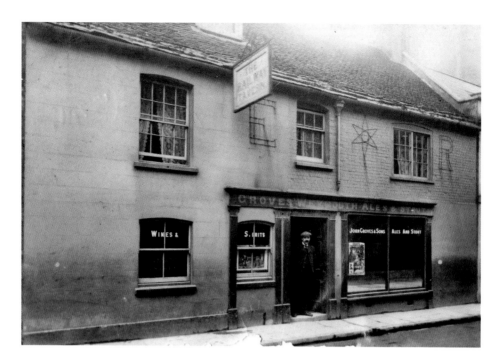

## Goldies

Located at the bottom of South Street, the Railway Tavern was a rare Groves Brewery pub in Dorchester. Long since demolished, it was opposite the New Inn, now also closed. The spirit of the beerhouse lives on, albeit updated, in and around High East Street. Goldies, formerly the Borough Arms, continues the alehouse tradition with ever changing guest beers from the entire Marston range. Along with Tom Browns and the Blue Raddle, this makes for a very refreshing trip to Dorchester.

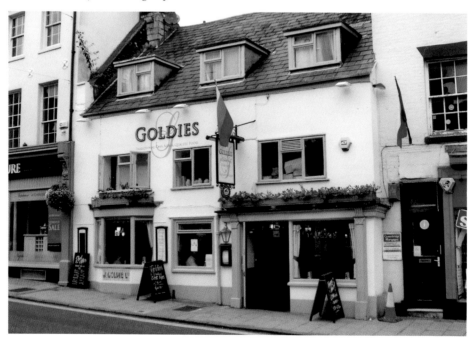

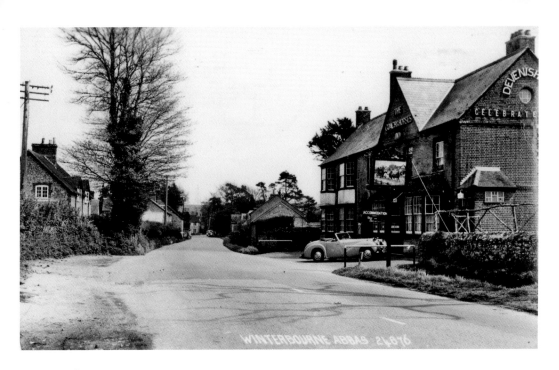

## Coach & Horses Inn

The name says it all. A large old coaching inn roadside on the A35 at Winterbourne Abbas, the Coach & Horses Inn dates back to 1841. But what's this? Times have a-changed and it is now what can only be described as a futuristic free house with a retro feel. It offers afternoon teas and coffees in a plush lounge area, a full restaurant to the left with a theatre kitchen, and an outstanding bar. It's a pub that caters for one's every need and deserves every success.

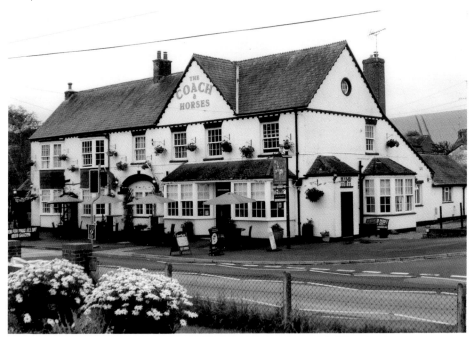

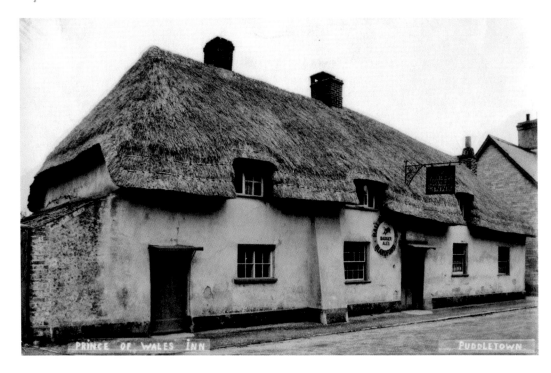

### Prince of Wales Inn

The original 400-year-old Prince of Wales Inn at Puddletown was described in an old guide as 'a real old-fashioned inn with an old-time chimney corner'. Sadly, in 1930 it was destroyed when a spark from a delivery lorry set fire to its thatched roof. Salvaged beams were incorporated into the new structure when the pub was rebuilt in typical 1930s style. The new Prince of Wales was to stay open for a further seventy years or so before being converted into flats in 2005.

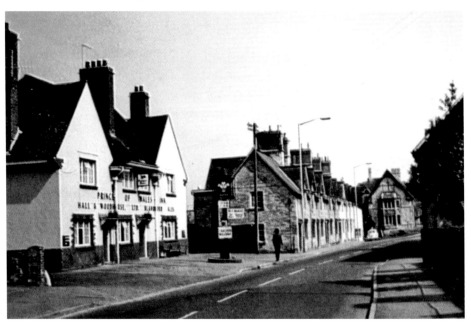

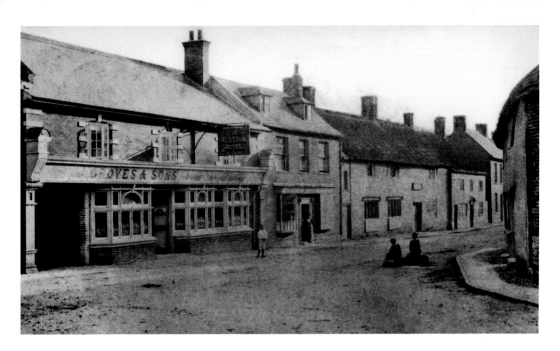

## Giant Inn

Another Dorset inn that came to grief through fire was the Red Lion at Cerne Abbas. Ironically, the ancient stone fireplace was the only structure to survive the 1898 fire. The pub was rebuilt in Victorian style by Groves Brewery, whose superb leaded advertising windows survive to this day. In 2006 its name was changed to the Giant Inn after the nearby fertility-giving Cerne Giant. The pub remains supportive of local breweries and is still a proper welcoming traditional hostelry.

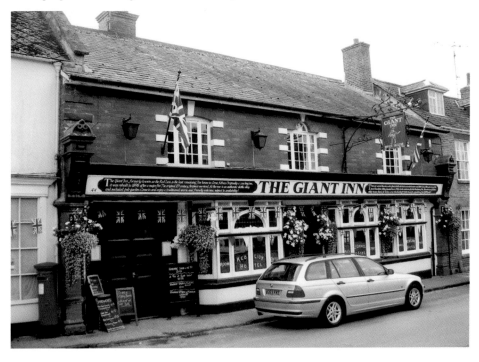

## Rest & Welcome Inn

On the A37 at Melbury Osmond stands the appealing Rest & Welcome Inn. Converted to a pub in the 1860s by Bruttons Brewery, it is mentioned in Thomas Hardy's *Interlopers at the Knap* as the 'Sheaf of Arrows Inn'. Wind forward to now and new tenants Emma and Russ Craven have recently started opening all day, serving ales from regional micros and using local produce. The skittle alley is being refurbished too. It is heartening to see such commitment to making the pub a success.

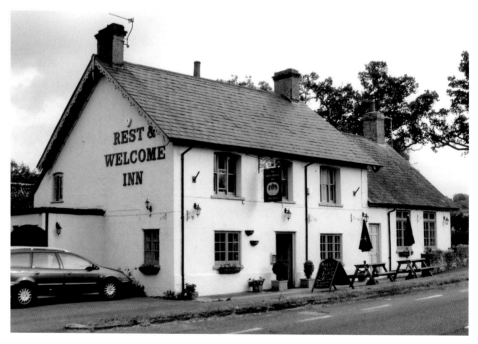

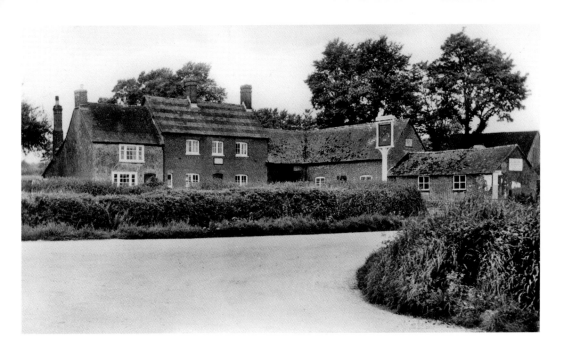

## Green Man

In the middle of an ancient royal hunting ground at Kings Stag, the Green Man is the perfect name for a pub in such verdant and fertile countryside. It is said that the Two Ronnies came to the area in the 1970s to film sketches of two yokels leaning on a five bar gate. After filming, still with holey jumpers and trousers held up by string, they came to the Green Man to sample the ale. Unfortunately no one had a camera so the opportunity to take a fine photograph for posterity was lost.

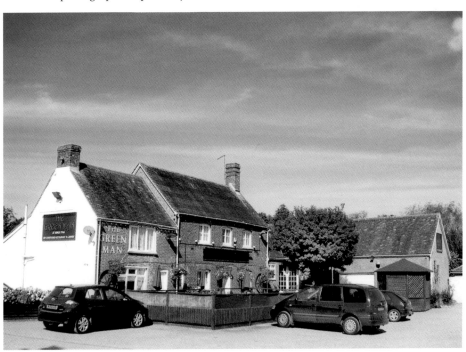

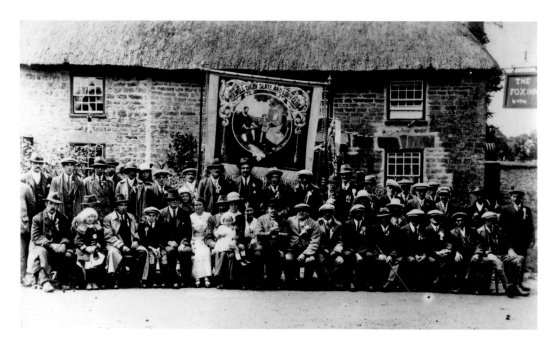

### White Hart

The Digby Slate & Loan Club are gathered in Edwardian times outside the Fox Inn at Holwell. The club was a type of friendly society and even had its own multi-coloured banner. At that time Holwell had two pubs, the Fox and the Red Lion. Both have long since closed. Now village residents' nearest pub is the 450-year-old White Hart at Bishops Caundle. Although it was until recently shut, new licensees Roger and Rachel Paull have reopened it as a free house and are quickly increasing trade at this wonderful pub.

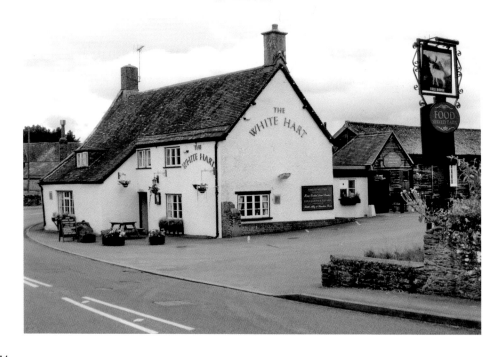

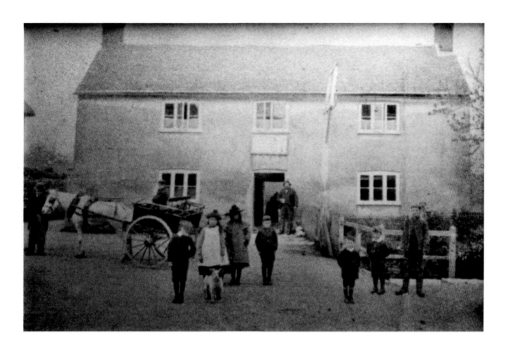

### Trooper Inn

It is uncertain when the Trooper Inn at Stourton Caundle first served ale, but it had been open for generations before it was bought by the Wyke Brewery in 1894. Since then the village has lost many of its amenities but the Trooper, as its name suggests, continues to be a community hub, now under the stewardship of Kevin and Zena. A popular annual beer festival is held alongside other traditions. To add to all that, the Trooper has just started brewing its own beer.

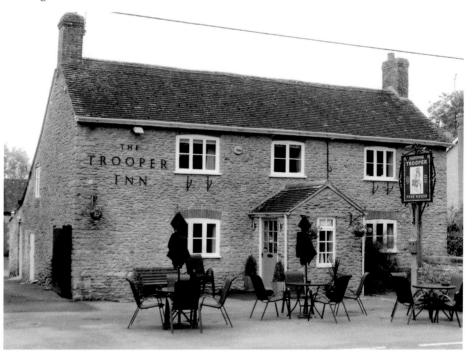

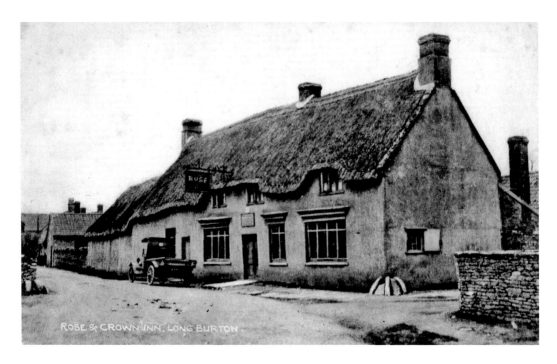

## Rose & Crown

In past times, the villagers of Longburton always supported the King. Legend has it that after a skirmish in 1645 several Royalist soldiers were given shelter at the inn, which thereafter took the name Rose & Crown. Amazingly, during restoration in 1946 an old sword was found thrust deep into the thatch. Beer was brewed behind the inn using well water until the nineteenth century. The old brewhouse is now converted to a dining room. Hall & Woodhouse now own this lovely village pub.

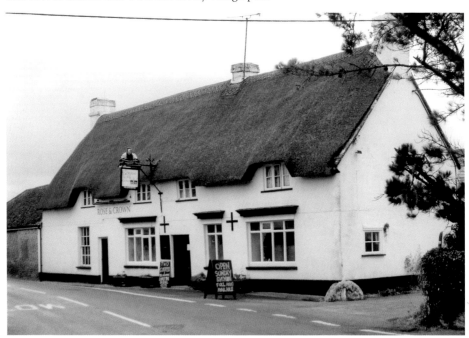

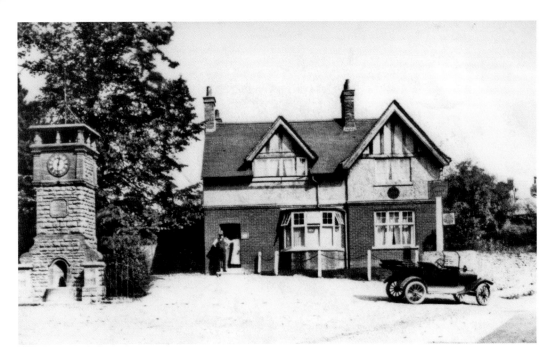

### The Lime Tree

The Lime Tree at Thornford started out as the Kings Arms in 1905, built on an old carpenter's yard overlooking the Victoria Diamond Jubilee clock tower. Still owned by the Digby Estate, in April 2012 its name was changed and the current licensees are surprised at how quickly both the image and reputation of the pub have moved on. Having won the West Dorset CAMRA Rural Pub of the Year 2012 award as the Kings Arms, it is evident that The Lime Tree is not resting on its laurels.

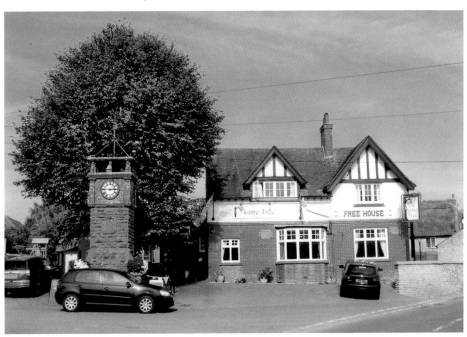

### Rose & Crown

Famously frequented in the 1930s by old-timers with half-moon beards, known as the 'lads of the village', the Rose & Crown at Bradford Abbas remains a traditional pub. Of course in the lads' day, beer was served directly from barrels behind the bar, the landlord kept restricted hours, the only food was bread & cheese (maybe with pickled onions) and the air was thick with smoke. Much has changed; the lads must have had hard lives, but would they prefer the pub today?

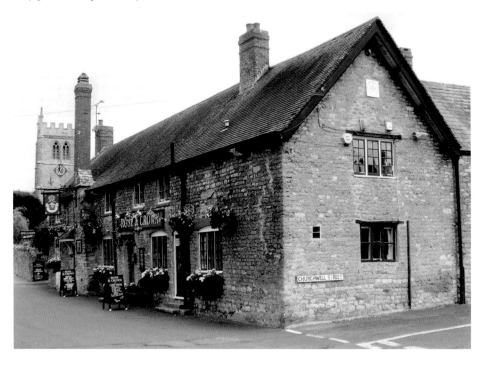

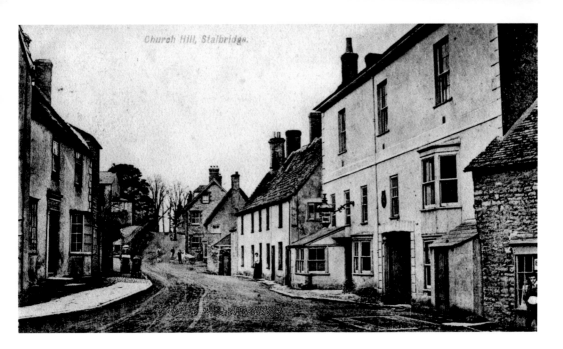

## Swan Inn

In Church Hill, Stalbridge, William Galpin was listed as brewing at the Red Lion in the 1750s. Sadly, this once important coaching inn closed around 1960. The Swan Inn also dates from the 1700s but is still serving foaming ale. Bucking the trend nowadays the Swan is a drinks-led pub. Locals say that in the eighteenth century, when John Wesley stopped to preach at Stalbridge Cross, customers left the comfort of the inns (the Red Lion and the Swan included) to pelt him with eggs.

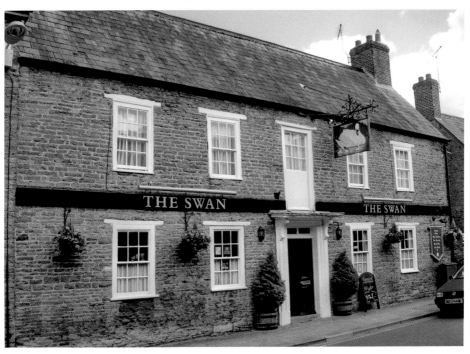

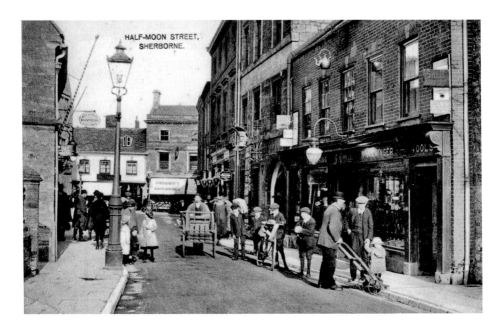

### Half Moon Hotel

The Half Moon Hotel was so important in Sherborne they named a street after it. The old Half Moon was trading by the 1750s, but in 1936 the owners purchased the adjoining building and subsequently rebuilt the hotel. Today the Half Moon is owned by Marston's and, much like their other Dorset hostelries, serves an excellent selection of ales. Around the corner in Westbury, the Sherborne Brewery produces its award-winning beer. Their ales 257 and Cheap Street are well worth seeking out.

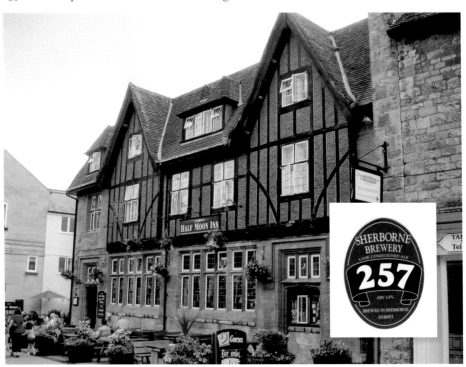

# CHAPTER 6

# West Dorset

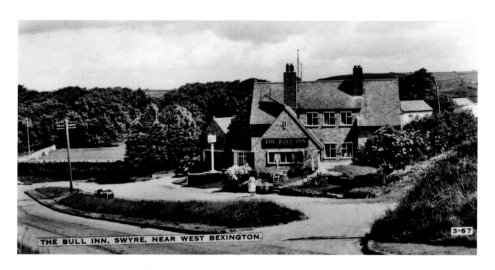

THE BULL INN, SWYRE, NEAR WEST BEXINGTON.

### Bull Inn

Originally the Bull Inn at Swyre was a much older thatched building that was used by smugglers for generations. Sadly it burnt down, but thankfully was rebuilt soon after in the late 1930s. It is only hearsay but the Portland spy ring may have met here, possibly sitting in the bay window to exchange secrets. The large bull above the door was painted black for many years. The bull was repainted bright red in 2012 to help boot trade and is causing a lot of interest!

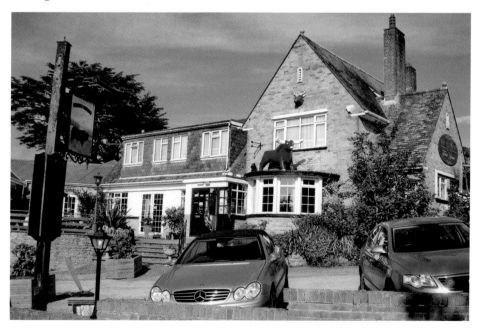

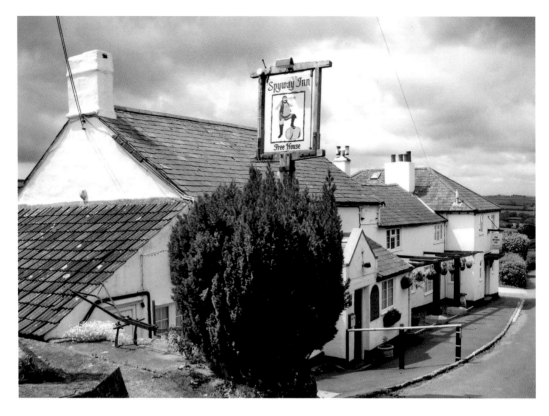

### Spyway Inn

With the Travellers Rest pub on the A35 closed, locals are well served a mile away in Askerswell by the Spyway Inn. First licensed in 1745 as the Three Horseshoes, the inn was used as a storage and distribution point by smugglers. To avoid confusion with the Three Horseshoes at Burton Bradstock, it was renamed after an old smuggling road. The Spyway was West Dorset CAMRA Pub of the Year 2011 – what better recommendation! Its garden is one of the best in Dorset too.

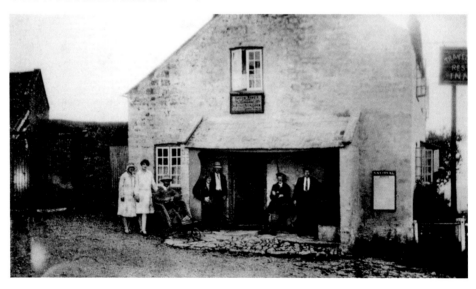

### New Inn

Unfortunately the Dove Inn at Burton Bradstock closed over a decade ago, but thankfully Burtonians have two excellent hostelries in the village. Should they wish to travel a tad further, there will always be a welcome at the New Inn at Shipton Gorge. The New Inn itself was rescued from closure by a community group who set up New Inn Support Ltd. With a mixture of fundraising, grants and sheer hard work, the pub was officially reopened in September 2006 by local MP Oliver Letwin.

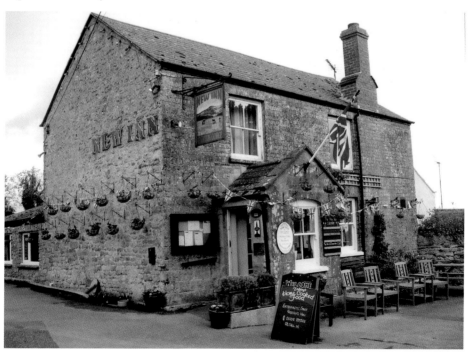

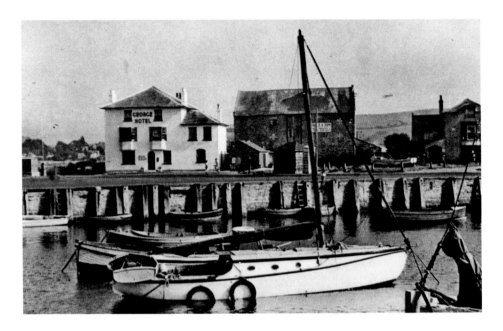

### The George

Overlooking the harbour at West Bay, the George has recently been refurbished to a very high standard and is a first-class establishment to visit whatever the weather. On a bright day it is a pleasure to sit outside and enjoy the sea air. When it is wet and windy, it is a comfort to be safe inside with the rain lashing against the windows. In every eventuality, the George serves a perfect pint of Palmers beer. The long-established, award-winning, family-run brewery is close by in Bridport.

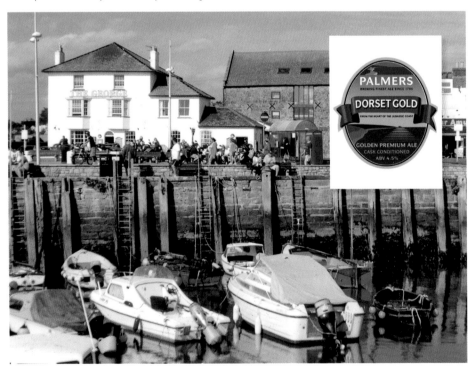

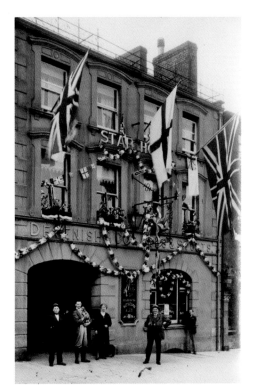

### Woodman Inn

The Star Hotel in West Street is seen in happier times. On 16 December 1942, a lone German bomber dropped several bombs on Bridport. The Star was hit and the landlord's son Jack Hecks was killed. The structural damage to the Star was repaired but it subsequently closed. In South Street, the Woodman Inn is a popular town-centre pub. It has a commendable community spirit and is involved with raising money for several charities. As a free house, it has an ever-changing selection of choice ales.

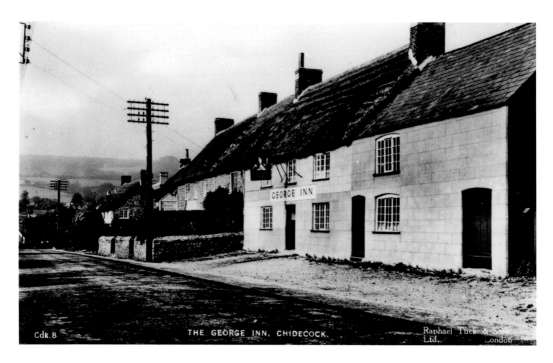

The George Inn, Chidecock.

### George Inn

The seventeenth-century George Inn at Chideock is a fine Palmers hostelry. Going back it was a 'cock house' providing extra horses to help carriages and carts up the steep hills on either side of the village. The pub has recently built up a fine reputation for its cuisine, but on 30 June 2012 something different was served. The Great Dorset Stinging Nettle Eating Competition was held at the George, and won by Sam Cunningham who ate 54 feet of nettle leaves in one hour. Ouch, it's thirsty work!

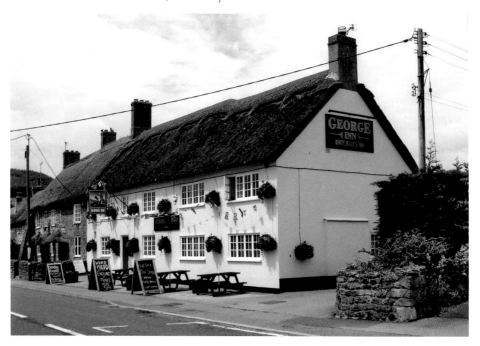

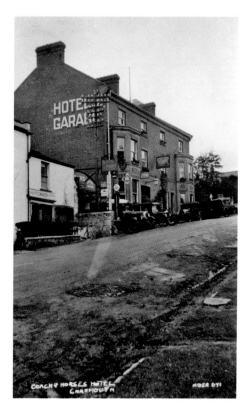

## Royal Oak

Going up the hill at Charmouth, the former grand old Coach & Horses Hotel closed in 2006 and is now flats. Further up is a fine Palmers hostelry, the Royal Oak, which is quite new as Dorset pubs go – it was first licensed in 1867! Pub games are popular here and regulars organise the RNLI Charity Christmas Swim at Charmouth beach. Back in the 1870s landlord John Wild was also the village crier and received a shilling for calling when Mead's coal boat arrived at Lyme Regis.

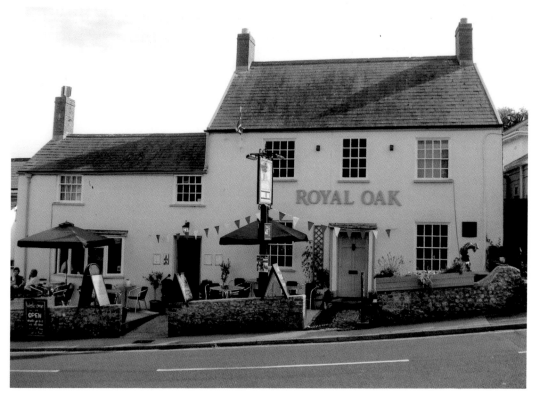

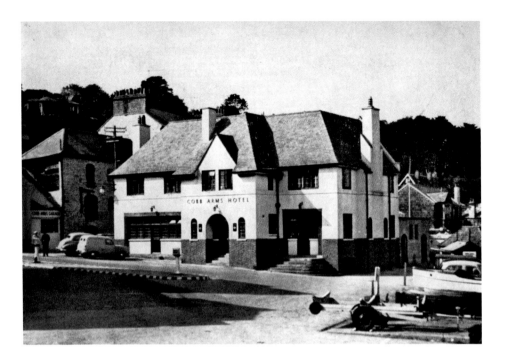

## Cobb Arms

The distinctive Cobb Arms overlooks the world-famous Cobb at Lyme Regis. Curving away, the harbour wall has been a safe haven for centuries but is expensive to maintain. In the fourteenth century an annual fundraising festival called 'The Cobb Ale' began and was held for the next 250 years until puritans ended the fun. The Cobb Arms also provides safe haven with well-kept Palmers ales. It is always a pleasure to watch goings-on in the harbour through the large picture windows.

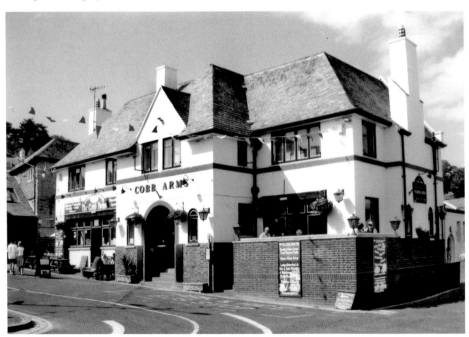

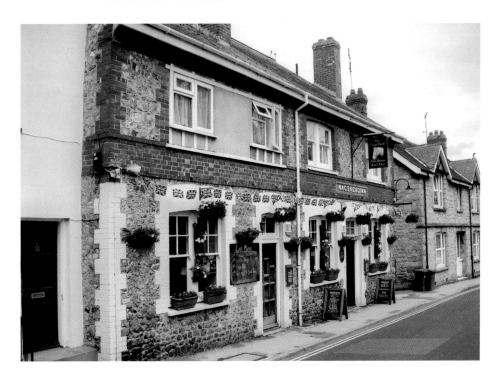

### The Nags Head Inn

On the western top of Lyme Regis, the Nags Head Inn in Silver Street remains a respected pub for locals and visitors with stunning views along the Jurassic Coast to Portland. In and around Lyme Regis, three microbreweries have recently opened and they organised the first beer festival at Lyme for 400 years. Pictured are Jon Hosking (ex-Town Mill Brewery, who now have Rainer Dresselhaus as brewer), John Whinnerah (Art Brew) and Mark Jenkin (Mighty Hop Brewery). Three Cheers.

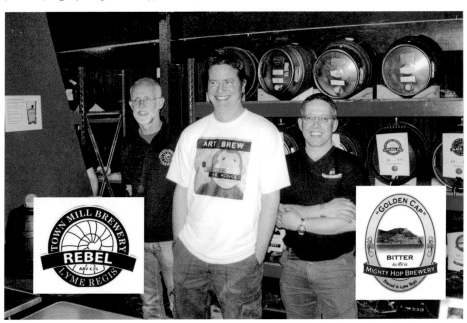

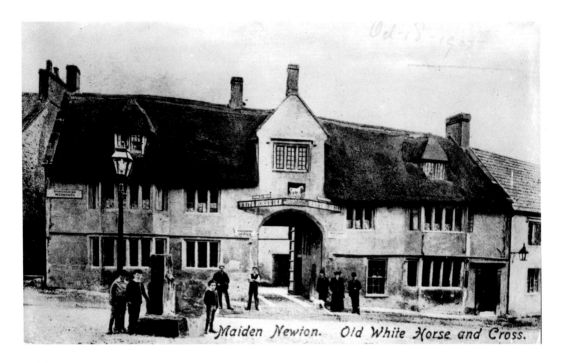

Maiden Newton. Old White Horse and Cross.

### White Horse

At Maiden Newton, the seventeenth-century White Horse was the most important coaching inn. However, in 1898 Devenish Brewery proposed to rebuild it. Thomas Hardy was sent to survey the inn and in a boarded-up attic he found some clothes 'supposed to be those of a man who was murdered'. Devenish prevailed. The new White Horse was built and was later described as 'most uninviting'. Ironically the architect was G. R. Crickmay, who had employed the young Hardy. Sadly the inn is now flats.

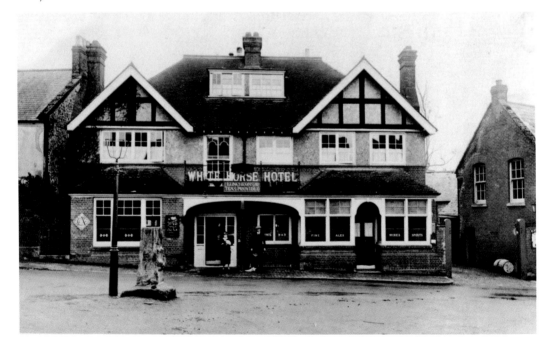

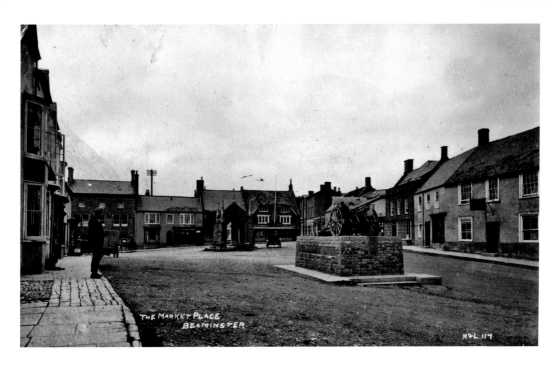

THE MARKET PLACE
BEAMINSTER

### The Greyhound

Dating back to 1750, the Greyhound is the oldest recorded pub in Beaminster. It provides good traditional service, top-notch Palmers ales and among its customers are the 'Ringers & Singers' from the local church. In the back snug, a wonderful inglenook fireplace was recently discovered, which doubles up as Santa's grotto. The landlord has plenty of drive as he is also the proud owner of a double-decker bus called 'Ruby the Routemaster', which is used to raise money for charity.

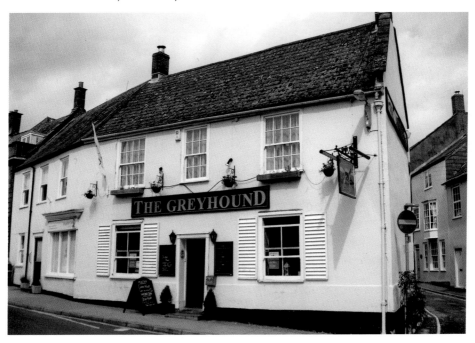

### Gollop Arms

The old Gollop Arms at Bowood, first licensed in 1789 as the Rising Sun, was destroyed by fire in October 1917. With the thatch ablaze, the alarm surprised the locals inside who were unaware of the danger. With commendable resolve, the landlords (the Whitemore family) continued to serve beer from the stables across the yard. They lived in the stables too until the new pub was built in 1923. Although the Gollop Arms closed in 1979, the occasional thirsty traveller still rings the bell.

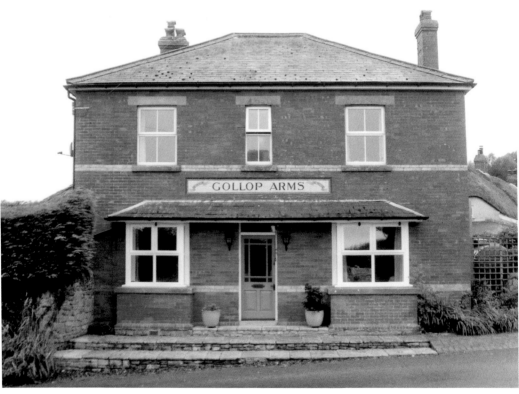

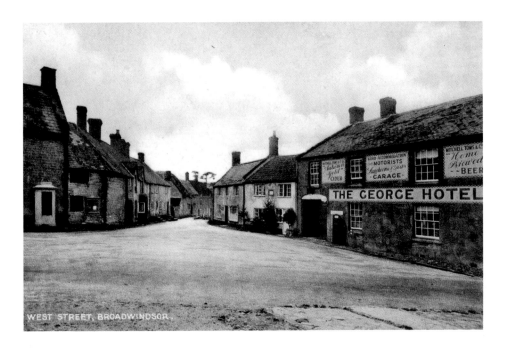

## White Lion

On one side of the square at Broadwindsor, the George Hotel is now a private dwelling. Charles II slept there for one night (23 September 1651) while on the run after the Battle of Worcester, unaware that a group of Parliamentarian cavalry were staying there too. On the opposite side, the White Lion can be traced back to 1761. It is a lovely traditional village pub serving liquid refreshment from Palmers Brewery. In 1939 landlord Hezekiah Tomkins supplemented his income by castrating sheep!

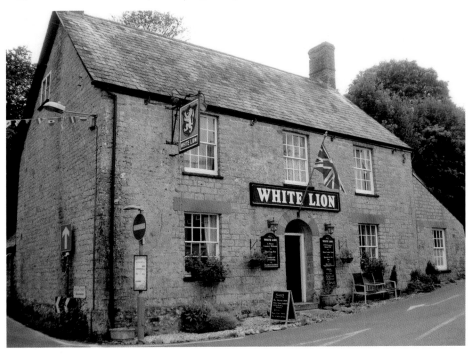

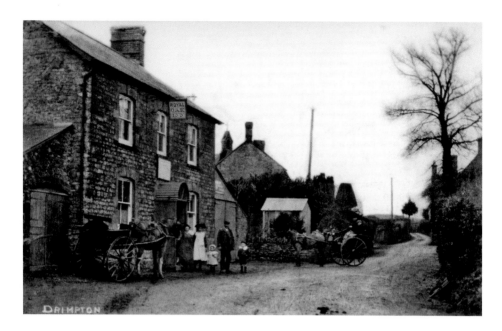

## Royal Oak

It is no wonder tourists love our countryside and village inns. Tucked away in the village of Drimpton, the Royal Oak is a traditional family-run pub that is a credit to Palmers Brewery. For generations the Royal Oak has remained at the centre of village life. There are monthly folk nights and the skittle alley has an alternative use. It houses the competition displays of the Leek & Fuchsia Club and the Charm Chrysanthemum Club. The entries are judged in private and then shown in public – 'bootiful'.

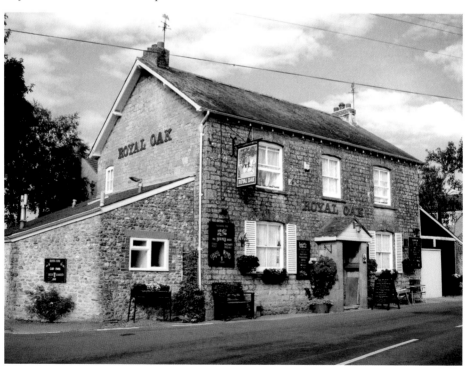

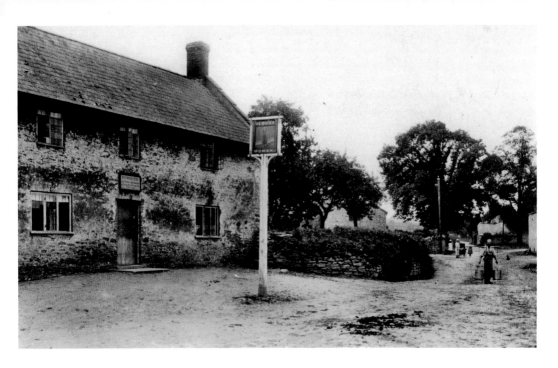

## Quiet Woman

The 300-year-old Quiet Woman Inn at Halstock was named after the village saint, Juthware. During the seventh century she came to a grisly end via her step-brother's sword. Legend has it that her decapitated body arose, picked up her severed head and placed it on the altar of an ancient local church. Sadly, the inn closed in the late 1990s but istill welcomes visitors, as it is now a guest house. A fine leaded window depicting the old pub sign still adorns the front door.

### Fox Inn

A picture postcard pub if ever there was one, the Fox Inn at Corscombe has all the character expected of a sixteenth-century, thatched, rose-covered country inn. Inside there are beamed ceilings, flagstone floors and inglenook fireplaces. The village is delightful with a stream and paddling ducks. But the Fox is closed ... Thankfully the pub has new owners and locals are hoping it will reopen in 2013. Certainly the Fox has all the right ingredients to flourish again. Here's to the future!

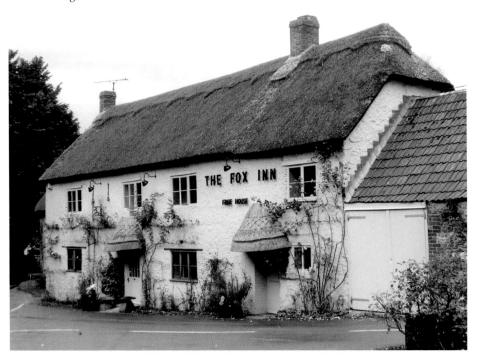